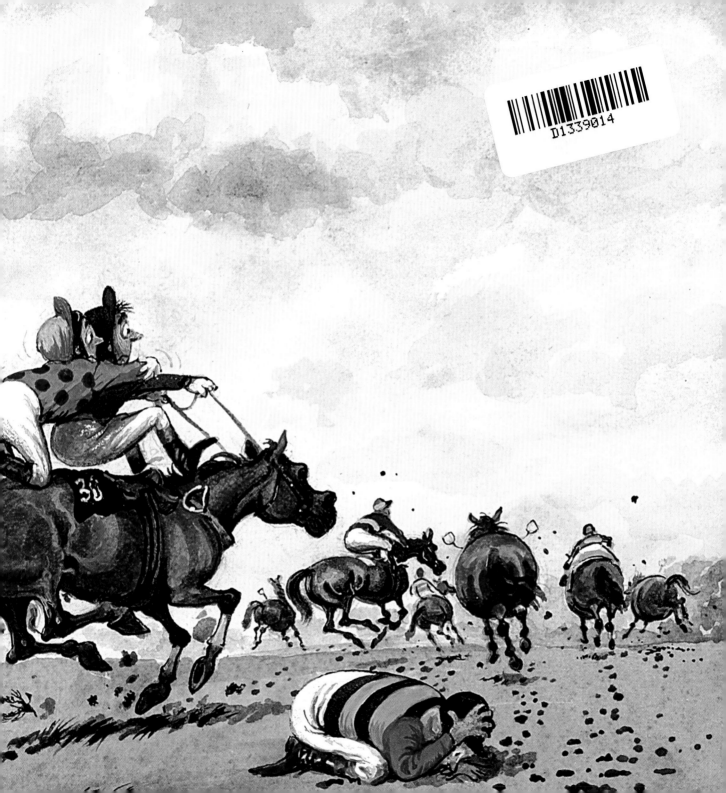

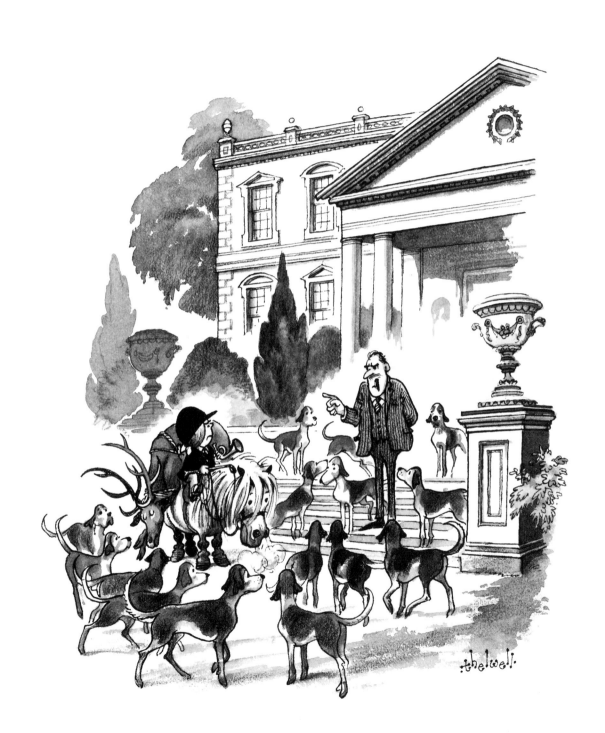

THE DEFINITIVE THELWELL

CHRIS BEETLES

8 & 10 Ryder Street, St James's, London SW1Y 6QB

Telephone 020 7839 7551 Facsimile 020 7839 1603

gallery@chrisbeetles.com www.chrisbeetles.com

Copyright © Chris Beetles Ltd 2009
8 & 10 Ryder Street
St James's
London SW1Y 6QB
020 7839 7551
gallery@chrisbeetles.com
www.chrisbeetles.com

ISBN 978-1-905738-14-4

Cataloguing in publication data is available from the British Library

Edited by Fiona Nickerson and David Wootton
Written by David Wootton
Design by Jeremy Brook of Graphic Ideas
Photography by Nemi Miller and Julian Huxley-Parlour
Colour separation and printing by The Midas Press

Front cover: *Rodeo* [**161**]
Front endpaper: *Tote Doble (or Two to One On)* [**164**]
Frontispiece: *Trials of Parenthood by Thelwell* [**125**]
Title page: *Never speak angrily to your pony* [**104**]
Back endpaper: *Phantom Stagecoach* [**165**]
Back cover: *Gone Away* [**159**]

CONTENTS

SHOCKS OF RECOGNITION: THE ACHIEVEMENT OF NORMAN THELWELL'S CARTOONS

Norman Thelwell is arguably the most popular cartoonist to have worked in Britain since the Second World War. For, in a career of over thirty years, he surveyed an impressive range of aspects of native life in an almost hyper-realistic style, so providing the public with a constantly entertaining visual indicator of social change. At the same time, he became almost synonymous with the particular subject of little girls and their fat ponies, which if colouring his reputation in the short term has only helped ensure his immortality.

Thelwell grew up between the wars, in a working-class urban environment that did not greatly value the visual arts. Indeed, the grammar school that he attended did not even have an art room. Yet, he was so driven by his desire and facility for drawing that he persevered, developing a skill with which he could record and interpret the world around him. That skill developed in tandem with his increasing experience of, and pleasure in, the countryside, and rural landscapes and activities would become intrinsic to his art. However, he was first valued as an artist during wartime service, being placed in intelligence because he could sketch positions and draw maps, and later appointed Art Editor – and all-purpose artist – of an army publication in New Delhi.

Working regularly for British periodicals from about 1950, and as a full-time illustrator from 1956, Thelwell absorbed and outgrew the influence of his rivals through that decade, and so established his own identity. Traces of those influences can be detected in the early drawings included here. For instance, the spirit of his *Punch* colleague, Rowland Emett (1906-1990), shines bright in the delicate fantasy of

Delusions of Grandeur (1953), in which an impoverished artist attempts to embellish his crumbling garret with Baroque *trompe l'oeil* [11].

Three years later, Thelwell appeared between the same *Lilliput* covers as Ronald Searle (born 1920), and something of that artist's robust style rubbed off on his illustrations of wartime narratives [1, 2]. But, in representing more earthy anarchism, and especially that of children, in cartoons for the *News Chronicle* and the *Sunday Dispatch*, he looked less to the Searle of St Trinian's, and more to the work of Giles (1916-1995) in the *Daily Express* [3, 4, 8]. Their panoramic settings and use of light and shade also seem indebted to Giles. Nevertheless, Thelwell's work was invariably grounded in his own experience, and his representation of the knowingness, irrepressibility, even cruelty of childhood was based on strong memories of his time as a student teacher and, indeed, as a schoolboy.

The recognisable character of Thelwell's art emerged in a series of stages: drawing regularly for *Punch* from 1952, publishing his first cartoon of ponies in 1953, and then producing his first book, *Angels on Horseback*, in 1957. His mature style was certainly confirmed in the late 1950s by, among other things, the solidity of the settings. This is epitomised by *Complete House Furnishers* (1957) [10], where the suspicion of the policewoman draws attention to Thelwell's mimetic mastery: it is because the windowful of furniture has so become a home that she believes that a burglar may be hiding under the bed.

Thelwell's humour often hinges on the tension between a world that is solid and believable – both materially and socially – and the flights of fancy that he introduces into it, and this 'in an era when other cartoonists were reducing their subject matter to shorthand squiggles' (Martin Plimmer, obituary, *Independent*, 10 February 2004). The viewer of a Thelwell enjoys the shock of recognition rather than experiencing the shock of the new.

The world that Thelwell explored most fully was that of the middle classes, which expanded in the decades following the Second World War as a result of gradually increasing prosperity. By so doing, he was also exploring his own progress, from modest beginnings in a Birkenhead two-up two-down to a comfortable life as a successful cartoonist in a Hampshire smallholding. As a result of his own social mobility, he could widen his focus, and place the middle classes in context, either by remembering his working-class roots or extending his eye towards the pursuits of the aristocracy: hunting, shooting, fishing … and opening the doors of one's stately home to the public.

In general though, Thelwell's *urban* settings centre on ordinary suburban or provincial streets. They show changes in domestic housing that, while suggesting broad improvements in standards of living, demand adjustments in life style from the inhabitants. Chief among these changes was the picture window installed into so many new houses, and tending to expose the lives of their occupants to their neighbours. Thelwell's cartoons of picture windows show the operation, or refusal, of 'one-upmanship', a term coined by the humorist, Stephen Potter, in 1952. So, when one character says of his neighbours, *You can't help but like them – they don't give a damn* (1966) [21], he punctures the aspiration of a wife determined to keep up with the Joneses.

Such direct competitiveness is even imitated by the children, as when one boy points to the window opposite and cries out, *He's got a bike* (1965) [18].

Relationships within families, across generations, and between neighbours are played out in some detail, both in the house and out in the garden. As with the classic British comedy of Norman Evans or Les Dawson, the garden fence becomes a particular site of much domestic drama, often as a boundary that is emphasised [72, 73] or violated [66]. Sometimes this drama can become quite extreme, turning to potentially violent retaliation, as when a wife tells her husband, *You'd better release their ball. They've kidnapped the cat* (1970) [24].

Thelwell may have been honest when he said to an interviewer in 1965 that he was 'more interested in the social than the political side of life … and had no axes to grind and no torches to bear'. However, the conflicts that he analysed are often microcosmically political, and the domestic conversations that he presented often turn on politics, however obliquely. For instance, the attempt of the United Kingdom to become a member of the Common Market, in 1961, finds its way to the tea table of a group of ladies struggling to remain superior [14]. Drugs and prostitution are also touched on, if rarely and lightly [25, 15]. Other serious subjects – such as abstract art – are cut down to size over coffee [20].

In looking beyond the home, Thelwell addressed the activities of work, rest and, especially, many forms of play. To his mind, even getting to work could be fraught with difficulty [49], and he generally represented the experience of driving on the British roads as chaotic and frustrating [53, 54, 55]. Work itself was shown as increasingly bureaucratic, mechanised and scientific, with little opportunity for

individuality or craftsmanship. The discovery and exploitation of oil and natural gas in the North Sea provided an uplift both to Britain's economy and its self-esteem [**80**, **81**, **82**, **83**], but the downside of this was the tendency towards what Thelwell termed 'the effluent society' (the title of the cartoon collection he published in 1971). And the likelihood remained that the entire system might break down, either temporarily (as the result of strikes) [**78**] or permanently (through large-scale unemployment) [**79**].

Neither did Thelwell consider the rural economy as offering much in the way of an answer. By the early 1960s, the farms that he depicted looked increasingly like factories and used industrial processes [**62**, **65**] or specialised in novel luxuries [**64**].

Similarly, holidays are shown as threatened by the commodification of mass-tourism, with fewer opportunities to get away from it all. Even if one makes it through the traffic jams, the beaches are likely to be as crowded as the roads, both at home [**43**] and abroad [**45**]. As a result, drastic measures needed to be taken to get a bit of space [**33**]. Some imaginative souls still manage to find stimulation from travel [**39**, **40**], while others enact ideal fantasy getaways, by taking canal barges through Venice [**35**, **38**].

Thelwell specialised in people trying to enjoy themselves against the odds, and through his oeuvre Britain appears as a nation of dogged enthusiasts. The significance of his highly popular images of pony clubs lies partly in the fact that they show this phenomenon starting at so young an age. His child riders, epitomised by Penelope, are amateurs in embryo, willing to take one of the ultimate challenges, that of handling a living creature. In many of the cartoons, they are depicted attempting to break their ponies in, with varying degrees of

success. The interplay of naturalism and exaggeration, which Thelwell so mastered, is particularly apparent here, with ponies kicking high into the air and sending their equestrians flying [**109**, **157**, **161**]. Yet, while they have their off days, the children still manage to keep smiling – on the whole.

That such passion for a pastime is not confined to the upper echelons, or indeed to country dwellers, is clarified by Thelwell's cartoons of urban, working-class football supporters. They embody Bill Shankly's famous comment that the sport is more important than life or death: shouting from the stands [**137**], arguing with the players [**126**], invading the pitch [**138**] and chasing the referee [**133**]. Their excitement can also turn to violence [**131**, **139**]. In Thelwell's world, they even petition the Prime Minister in the hope of overturning the ref's decision [**134**].

At heart, Thelwell was a cartoonist of common human experience, experience that is both quotidian and shared. The extreme, surreal moments serve only to emphasise this, as do the calm, bucolic backgrounds. And it is because he placed that experience in an accurately evolving social context that his achievement is bound to last.

David Wootton

NORMAN THELWELL: A BIOGRAPHICAL CHRONOLOGY

1923 **3 May**: Born 25 Crofton Road, Tranmere, Birkenhead, Cheshire, the younger of two sons of Christopher Thelwell, a maintenance engineer at Lever Brothers, Port Sunlight, and his wife, Emily (*née* Vick)

Educated at Well Lane Primary School, and then at Rock Ferry High School, Birkenhead, where he soon began to show a talent for drawing, though the school had no art room

Had childhood experiences of the countryside on trips in the locality and on holidays on a farm at Corwen, in north-east Wales

1933 Produced his earliest surviving drawing, a self-portrait, which a teacher had marked with the words 'V good indeed'

1938 Sold his first drawing, of fifteen chickens

1939 Joined a Liverpool dock office as a junior clerk, spending nights fire watching

1942 **February**: Despatched to the Infantry Training Centre, Squires Gate, near Blackpool

Posted to Watford to join the second battalion of the East Yorkshire Regiment; soon after, was transferred to the intelligence section because of his ability to sketch positions and draw maps, and moved around Britain to undertake operations

1944 Completed his training as a wireless operator at Long Eaton, Derbyshire, where, in the NAAFI, he discovered the magazine, *The Artist* (which would publish some of his drawings in August 1945); took some evening classes at Nottingham School of Art, where he met fellow student, Rhona Ladbury, his future wife, who was serving in the Land Army

Posted to India with the Royal Electrical and Mechanical Engineers

Had his first humorous drawings published in *Victory*, an army magazine

1945-46 Promoted to the rank of Sergeant and appointed Art Editor of a new army publication for the Indian Royal Electrical and Mechanical Engineers in New Delhi, drawing everything for it. While in that position, had his first cartoon published in *London Opinion* and a weekly series of caricatures of Indian service leaders in *News Review*; also designed some new uniforms for the Indian Army and a flag for the Boys' Regiment Indian Armoured Corp

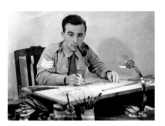

Sergeant Norman Thelwell, a photograph sent from India to Rhona Ladbury, his wife to be, *circa* 1945

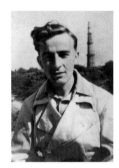

Thelwell, in front of the 13th century Qutb Minar, near Delhi, the tallest tower in India, *circa* 1945

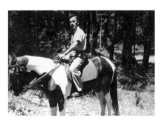

Thelwell, in a rare shot on a horse, in the grounds of the summer residence of the Governor of the United Provinces at Nainital, in the Kumaon foothills of the outer Himalayas, *circa* 1945

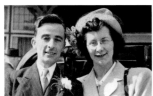

Norman and Rhona Thelwell in Attenborough, Nottinghamshire, on their wedding day, 9 April 1949

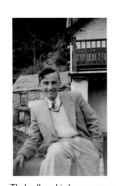

Thelwell on his honeymoon in Clovelly, Devon, April 1949

Thelwell in Codsall, Staffordshire, 1950s

1946 **November**: Returned to England; his job as a clerk had been held for him in Liverpool, but one day of it was enough

1947-50 Taking advantage of an ex-serviceman's grant, studied at Liverpool City School of Art, under Henry Percy Huggill (Principal) and Geoffrey Heath Wedgwood, and completed the five-year degree course in three years; his final year's teaching practice included time at his former primary school, Well Lane

1949 **9 April**: Married Rhona Ladbury at Attenborough Church, Long Eaton, during an end-of-term break, and they honeymooned at the Red Lion, Clovelly (paid for by increasing contributions to *Men Only*, *London Opinion* and *Everybody's Weekly*

Recommended by Wedgwood to the Rev Marcus Morris, who was seeking artists to work on his magazine *The Anvil* and a new comic, *Eagle*

1950 **February**: Began to have cartoons published in *The Anvil*

8 February: First cartoon appeared in *Punch*

31 March: Son, David Thelwell, was born in Birkenhead (he became a wildlife illustrator)

April: Thelwell produced 'Chicko', a weekly three-panel pantomime, which ran in the first six issues of the *Eagle* before disappearing for a few months

Moved with his family to Wolverhampton and began to teach Design and Illustration at Wolverhampton College of Art; soon settled in Codsall, Staffordshire

August: 'Chicko' returned to the pages of *Eagle* and appeared regularly until March 1962

1952 **June:** Began a 25-year relationship with *Punch* that would encompass 60 covers and over 1,500 drawings

1953 **9 June**: Penelope Thelwell was born in Wolverhampton

19 August: First pony cartoon published in *Punch*

1956 **Summer**: Left teaching to take up illustration full-time, and worked as political cartoonist for the *News Chronicle*, producing 387 cartoons until its demise in 1960

1956-57 Contributed to *Lilliput*

1957 Published *Angels on Horseback*, the first book of many volumes of cartoons

1959 Moved to Braishfield, near Romsey, Hampshire, buying and subsequently restoring 'Cherry Hill', Braishfield Road and the two dilapidated cottages on the estate

1960 Worked for the *Sunday Dispatch*, until its demise in 1961

1962-71 Worked for the *Sunday Express*

1962 Published *A Leg at Each Corner*, the contents of which were serialised in the *Sunday Express* and led to the development of the strip cartoon characters Penelope and Kipper

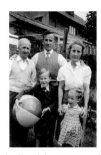

Thelwell, with his parents and his children, Birkenhead, Cheshire, *circa* 1957

1966 Became a founder member of the British Cartoonists' Association

circa 1966 Bought Addicroft Mill, near Callington, Cornwall, and subsequently restored it (recounted this experience in *A Millstone Round My Neck*, 1981, in which he called it 'Penruin Mill')

1968 **March**: Moved to Herons Mead, off Stockbridge Road, Timsbury, Hampshire, and developed the property (recounting the experience in *A Plank Bridge by a Pool*, 1978)

Thelwell in his studio at Braishfield, Hampshire, mid 1960s

1970 Designed a series of six table mats, which proved the genesis of his sporting prints

1971-76 Worked for *Tatler*

1977 Began to concentrate on landscape painting

1986 Published *Wrestling with a Pencil*, his autobiography

1989 Major retrospective at the Chris Beetles Gallery

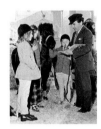

Thelwell signing books at a pony club, *circa* 1970

2003 Museum retrospective, 'Thelwell Country' began to tour the UK

2004 **7 February**: Died in Winchester, Hampshire

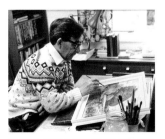

Thelwell painting in his studio at Herons Mead, Hampshire, early 1980s

1: THE EARLY YEARS

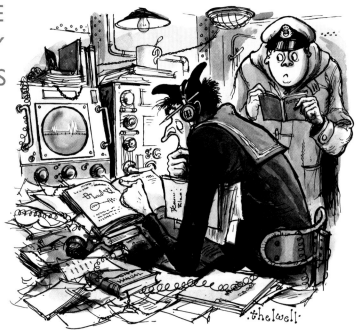

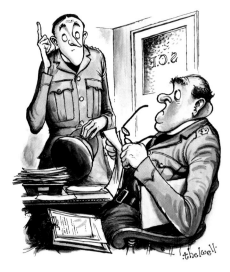

1 The Radio Cabin (left)
signed
pen ink and watercolour
6 x 6 ½ inches
Illustrated: *Lilliput*, July 1956, page 35, 'Where the Fighting was Thinnest – 5: Friend or Foe?' by Edward Hyams

2 'I'm your SCF, Insight,' he said, 'the letters stand for Senior Chaplain to the Forces' (above)
signed
pen ink and watercolour
6 x 5 ½ inches
Illustrated: *Lilliput*, July 1956, page 29, 'Where the Fighting was Thinnest – 9: Clergyman in Khaki' by James Insight

3 I was gazing up – 'aving one minute's silence for that poor little Russian doggy when that thieving, four legged son of a mangy...
signed
inscribed with title and 'If the dog situation changes before Saturday the first part of the caption could be changed to "I was just thinking about that poor little Russian doggie etc"' below mount
pen ink and zippatone with crayon; 7 ½ x 12 inches
Probably illustrated in the *News Chronicle*

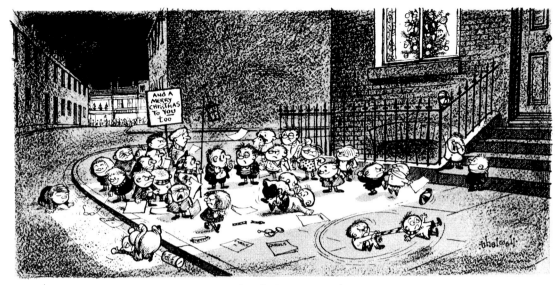

4 Let's cut out the competition – have a giant merger and demand exorbitant prices
signed and inscribed with title
pen ink and zippatone with crayon
6 ¾ x 12 ¼ inches

" LET'S CUT OUT THE COMPETITION – HAVE A GIANT MERGER AND DEMAND EXORBITANT PRICES . "

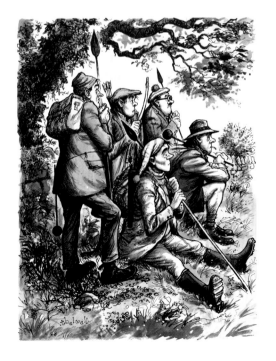

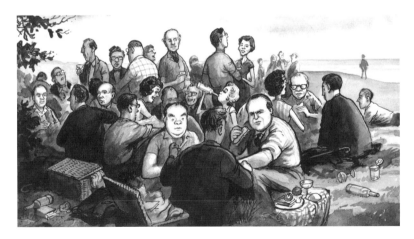

5 Hunters
signed
pen ink and watercolour with bodycolour
10 ¾ x 8 ¼ inches
Illustrated: *Lilliput*, January 1957, page 52,
'The Name's McGilligan' by Kem Bennett

6 Critics' Picnic
pen ink and monochrome watercolour
3 ¾ x 7 inches

7 You mean to say you've been working for the Russians since Balaclava?
signed and inscribed with title
pen ink and zippatone with crayon
7 ½ x 10 ½ inches
Probably illustrated in the *Sunday Dispatch*

8 Right men! shall we blast 'im off for Hallow-e'en or hold 'im back for the 5th of November?
signed and inscribed with title
pen ink, monochrome watercolour and zippatone
7 ¾ x 12 ¾ inches

2: AT HOME WITH THELWELL

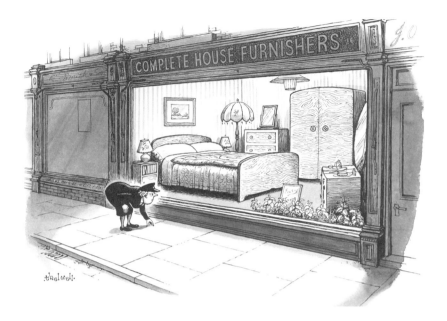

9 ...And of course its people
signed with intial 't'
pen and ink
6 ½ x 5 ¼ inches
Illustrated: *Punch*, 16 July 1958, page 91;
Norman Thelwell, *Thelwell Country*,
London: Methuen, 1959, page 96;
Norman Thelwell, *Wrestling with a Pencil*,
London: Methuen, 1986, page 83

10 Complete House Furnishers
signed
pen ink and monochrome watercolour
7 x 10 ½ inches
Illustrated: *Punch*, 13 November 1957,
page 568

11 Delusions of Grandeur
signed
pen ink and monochrome watercolour
9 ½ x 11 ½ inches
Illustrated: *Punch*, 15 April 1953, page 461

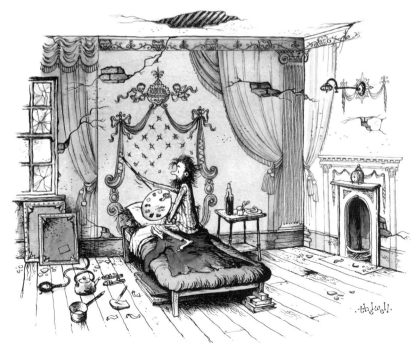

12 OK, they've stopped the bleeding
signed
inscribed with title below mount
pen ink and monochrome watercolour with crayon
4 ¼ x 7 ½ inches

13 Beware of the Swimming Pool
signed
monochrome watercolour with pen and ink
4 ½ x 9 ½ inches
Illustrated: *Punch*, 3 February 1965, page 165

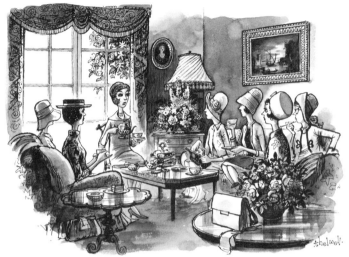

14 … Italy won't be abroad, France won't be abroad – if we join the Common Market where are we to go for our holidays?
signed and inscribed with title
monochrome watercolour with pen and ink
10 ½ x 12 inches
Illustrated: *Punch*, 12 July 1961, page 55

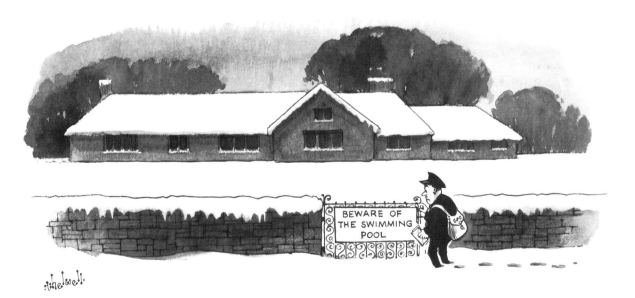

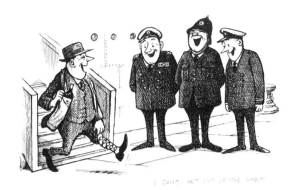

'I CAN'T GET OUT OF THE HABIT'

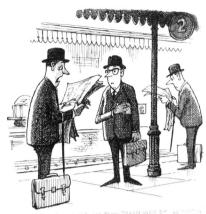

'MY GOD... "THE TIMES" HAS BEEN TAKEN OVER BY "LE MATIN"'

IF WE JOIN

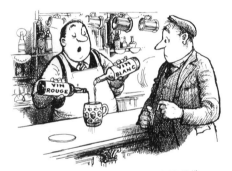

'HALF OF MIXED IT IS'

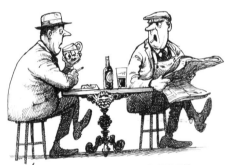

'HEIDELBURG LET ME DOWN ON THE FOUR-AWAYS'

15 If We Join
'I can't get out of the habit'
'My God! "The Times" has been taken over by "Le Matin"'
'Half of mixed it is'
'Heidelburg let me down on the Four-Aways'
'What do you want with your bacon – a little Lion – a little Eagle or a Fleur-de-lis?'
'We'll have hordes of Italians after our jobs'
signed and inscribed with title and captions
pen and ink
14 x 11 ½ inches
Illustrated: *Punch*, 13 September 1961, page 399

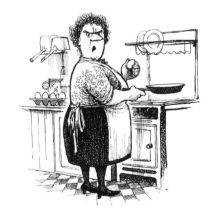

'WHAT DO YOU WANT WITH YOUR BACON – A LITTLE LION – A LITTLE EAGLE OR A FLEUR-DE-LIS?'

'WE'LL HAVE HORDES OF ITALIANS AFTER OUR JOBS'

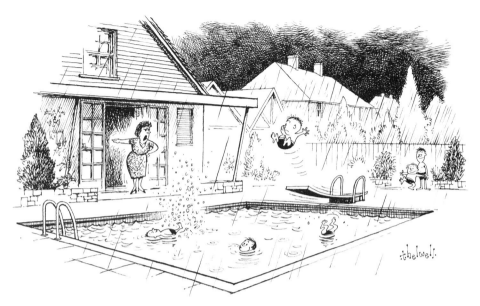

**16 Come out of there this minute!
It's going to pour with rain**
signed and inscribed with title
pen and ink
7 x 9 ½ inches
Illustrated: *Sunday Express*, 22 August
1965, page 13

17 Unwelcome Carollers
signed
pen ink, monochrome watercolour and crayon
6 ¾ x 9 inches

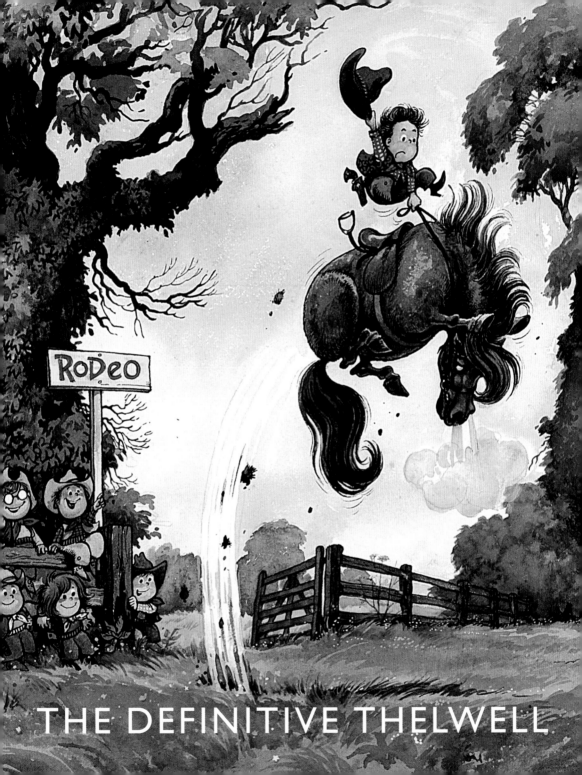

THE DEFINITIVE THELWELL

Chris Beetles presents

THE DEFINITIVE THELWELL

The first selling show of Norman Thelwell in 20 years

The most popular cartoonist since the Second World War, Thelwell is best remembered for his little girls and their cheeky fat ponies. However, he was a wide-ranging artist who surveyed an impressive range of social subjects for a variety of newspapers and periodicals, most notably *Punch*.

Private View
Tuesday 12 May 2009
6-8 pm

Exhibition runs until 13 June
10am-5.30pm Monday-Saturday

Chris Beetles
8 & 10 Ryder Street
London
SW1Y 6QB
020 7839 7551
gallery@chrisbeetles.com

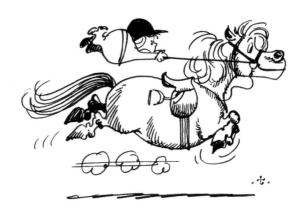

www.chrisbeetles.com

Catalogue order form

The Definitive Thelwell, a 100 page, colour catalogue with 177 illustrations, an extended biography and a full bibliography

Please send me copy/ies @ £15 each (plus £2 p&p in the UK)

Please charge my Visa/Master Card/Switch/Maestro no: ..

Exp: /...... Issue (if applicable): Security code (last 3 digits on signature strip):

OR I enclose a cheque for £

Name ..

Address ..

Tel ... Email ..

Please detach form and send to: **Chris Beetles**, 8 & 10 Ryder Street, London SW1Y 6QB

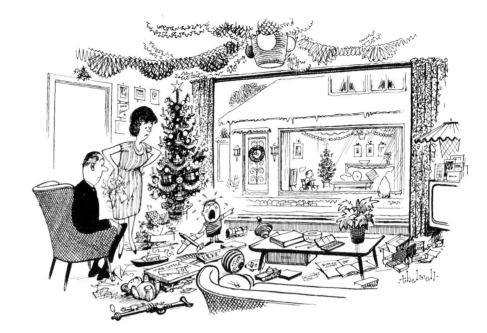

18 He's got a bike
signed
printed caption pasted below mount
pen and ink
6 x 9 ½ inches
Illustrated: *Sunday Express*,
26 December 1965

**19 I'm sick of protest
songs – every time
they're told to go to bed**
signed and inscribed with title
pen and ink
6 ½ x 8 ½ inches
Illustrated: *Sunday Express*,
16 January 1966, page 21

20 We bought it mainly to cover a damp patch
signed and inscribed with title
pen ink and monochrome
watercolour with crayon
11 ½ x 5 ½ inches
Illustrated: *Punch*, 5 January 1966, page 5

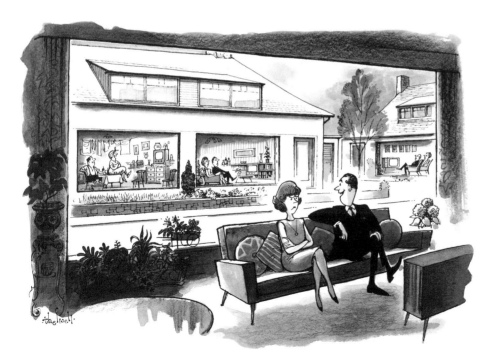

21 You can't help but like them – they don't care a damn
signed
inscribed with title below mount
pen ink and monochrome watercolour
7 ½ x 10 ½ inches
Illustrated: *Punch*, 13 July 1966, page 54; Norman Thelwell, *Thelwell's Book of Leisure*, London: Methuen & Co, 1968, page 46

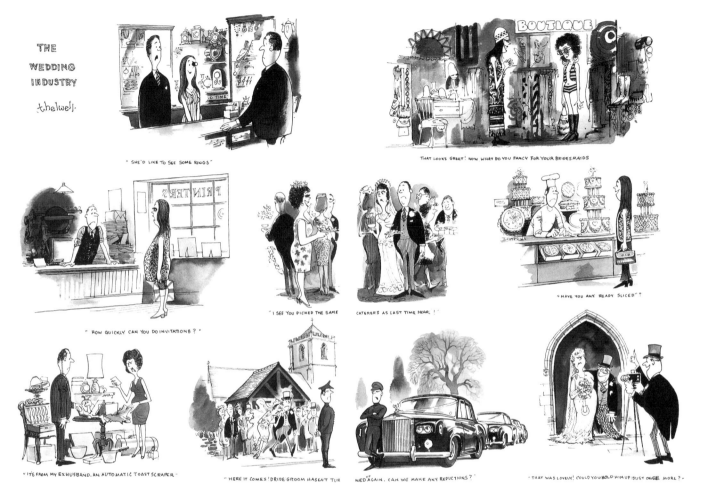

THE
WEDDING
INDUSTRY

thelwell.

"SHE'D LIKE TO SEE SOME RINGS"

THAT LOOKS GREAT! NOW WHAT DO YOU FANCY FOR YOUR BRIDESMAIDS

"HOW QUICKLY CAN YOU DO INVITATIONS?"

"I SEE YOU PICKED THE SAME CATERERS AS LAST TIME DEAR."

"HAVE YOU ANY READY SLICED"?

"IT'S FROM MY EX HUSBAND. AN AUTOMATIC TOAST SCRAPER"

"HERE IT COMES! BRIDE GROOM HASENT TUR"

"NED AGAIN. CAN WE MAKE ANY REDUCTIONS?"

"THAT WAS LOVELY! COULD YOU HOLD HIM UP JUST ONCE MORE?"

22 The Wedding Industry

'She'd like to see some rings'

'That's look great! now, what do you fancy for your brides maids?'

'How quickly can you do invitations?'

'I see you picked the same caterers as last time dear!'

'Have you any ready sliced?'

'It's from my ex husband. Automatic toast scraper'

'Here it comes! Bride groom hasent turned up again. Can we make any reductions?'

'That was lovely! Could you hold him up just once more?'

signed and inscribed with title

pen ink and monochrome watercolour

two panels, each measuring 14 ¾ x 10 ¾ inches

23 She knows we're on to her. She's got rid of the stuff
signed and inscribed with title
pen ink and monochrome watercolour
with crayon and pencil
8 x 11 inches
Illustrated: *Punch*, 12 February 1969, page 222

24 You'd better release their ball. They've kidnapped the cat
signed and inscribed with title
pen ink, monochrome watercolour
and crayon with pencil
7 x 9 ¾ inches
Illustrated: *Punch*, 10 June 1970, page 878

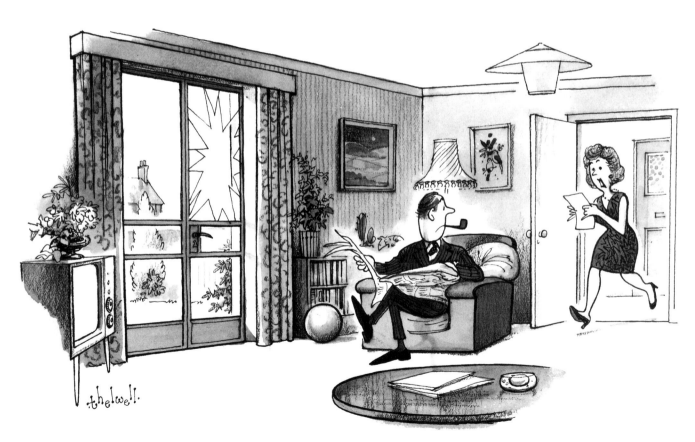

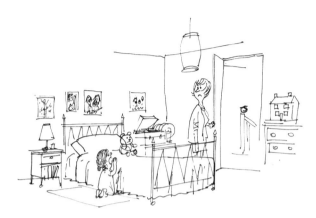

25 ... And keep me off drugs ...
inscribed with title
pen and ink
6 ¼ x 7 ¾ inches

26 Man's Best Friend
pen and ink
9 ½ x 7 inches

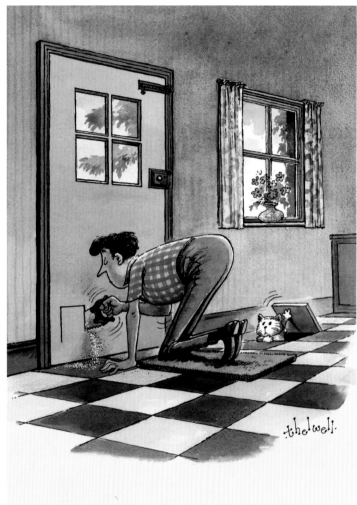

27 The Cat Flap
signed
pen ink and watercolour
with bodycolour
10 ¼ x7 inches
Similar to Norman Thelwell,
Thelwell's Magnificat, London:
Methuen, 1983, '... and his own
cat-door so that he can get in and
out when he wishes'

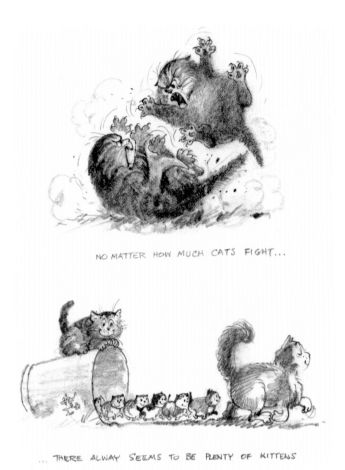

NO MATTER HOW MUCH CATS FIGHT...

... THERE ALWAY SEEMS TO BE PLENTY OF KITTENS

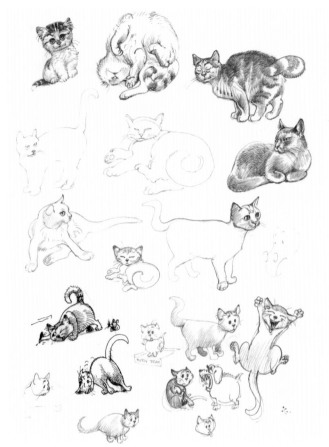

**28 No matter how much cats fight …
there always seems to be plenty of kittens**
inscribed with title
pencil
8 ¾ x 6 ½ inches
Preliminary drawing for Norman Thelwell, *The Cat's Pyjamas*,
London: Methuen, 1992, pages 88 and 99

29 Cats
signed with initial 't'
pencil with pen and ink
11 x 9 inches

3: HOLIDAYS AND TRAVEL

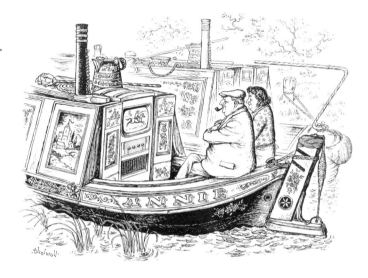

30 Annie
signed
pen and ink
7 ¾ x 10 ½ inches
Illustrated: *Punch*, 16 June 1954,
page 718

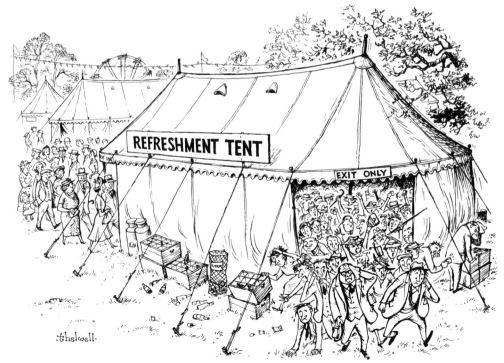

31 Refreshment Tent
signed
pen and ink
7 ¾ x 10 ¾ inches
Illustrated: *Punch*, 23 June 1954,
page 740

32 I don't know how these chaps think them up!
signed
inscribed with title below mount
pen and ink
9 x 11 inches
Illustrated: *Punch*, 6 July 1960, page 5

33 Enjoying the Beach
signed
pen and ink with zippatone
6 ¾ x 10 ½ inches
Illustrated: *Punch*, 12 August 1959, page 41;
Norman Thelwell, *Thelwell in Orbit*, London:
Methuen, 1961, page 59

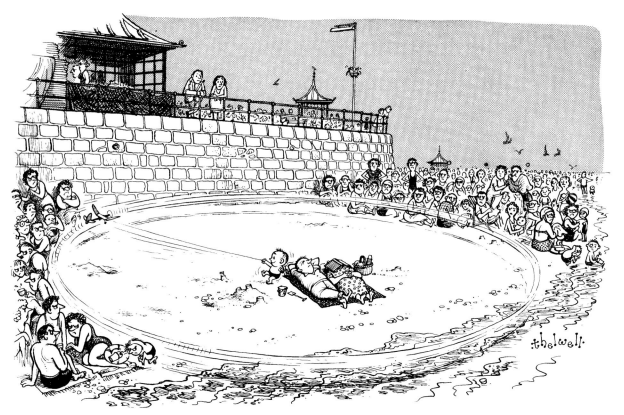

The Age-old Custom of Beating the Balm Cake at Abbotts Dawling

In 1960, the art historian, Bevis Hillier (born 1940), produced the winning entry in a *Punch* competition calling for a piece of 'imaginary art criticism'. His prescient invention was Hannibal Potter, a minimalist abstract painter who allowed just 'one, almost two dots of colour' to enliven each of his canvases.

Hillier took the artist's name from that of a seventeenth-century rector with Royalist sympathies who had been ousted from his living following the Civil War. His prize was a *Punch* cartoon of his choice, or rather of his second choice, for he selected this fine example of work by Thelwell, only after his original request for Ronald Searle's drawing of T S Eliot had been refused.

34 The Age-old Custom of Beating the Balm Cake at Abbotts Dawling
signed
inscribed with title below mount
pen ink and watercolour
with bodycolour
12 ¾ x 10 ½ inches
Provenance: Bevis Hillier
Illustrated: *Punch*, 13 April 1960, page 512
Exhibited: 'Wonderland: An Exhibition of Children's Book Illustrations', Cecil Higgins Art Gallery, Bedford, July-October 2001

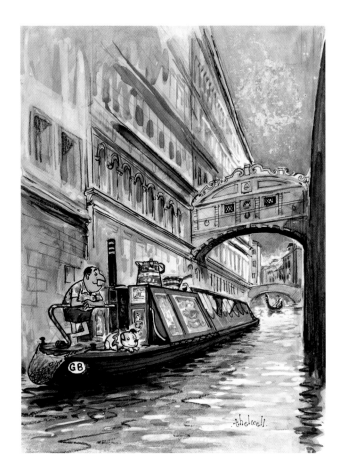

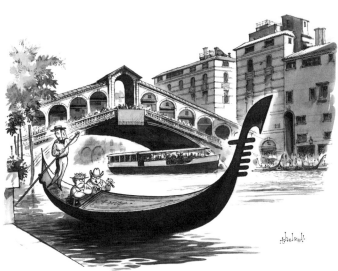

35 Canal Holiday in Venice
signed and inscribed with title
watercolour with pen ink and crayon
10 x 7 ½ inches
Preliminary design for Pu*nch*,
14 June 1967, front cover

36 You read political significance into *everything*. It just so happens that no one's wanted to pinch you up to now
signed and inscribed with title
pen ink and monochrome watercolour with pencil
10 x 11 inches
Illustrated: *Punch*, 15 April 1964, page 551

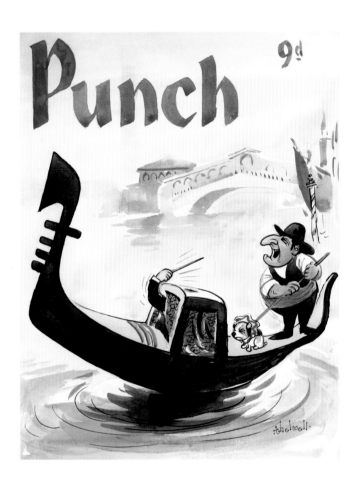

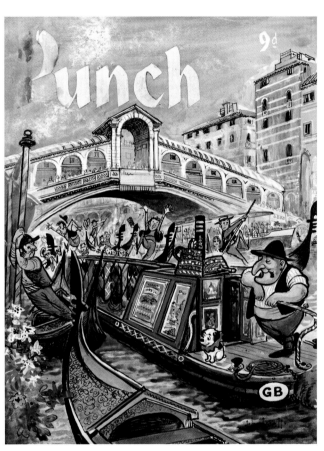

37 How they love to sing in Venice
signed
pen ink and watercolour with pencil
10 ½ x 8 ¼ inches
Preliminary design for *Punch* front cover

38 On a Venetian Canal
signed
watercolour with pen ink, bodycolour and pencil
11 x 8 ½ inches
Preliminary design for *Punch* front cover

39 No! I still don't see any resemblance
signed
inscribed with title below mount
pen and ink
6 ¼ x 7 ½ inches
Illustrated: *Punch*, 30 August 1961,
page 320

40 I remember one terrible night back in Sixty Three, on the Exeter By-pass
signed, and inscribed with title and
'Chiswick Flyover'
pen ink and monochrome watercolour
with crayon
8 x 12 inches
Illustrated: *Punch*, 23 June 1965, page 913;
Norman Thelwell's Book of Leisure, London:
Methuen, 1968, page 33, as 'I remember
one terrible night back in Sixty-Three, on
the Chiswick Flyover'

41 I didn't even know we'd played them in the World Cup
signed and inscribed with title
pen ink and monochrome watercolour
7 ½ x 11 inches
Illustrated: *Punch*, 27 July 1966, page 133

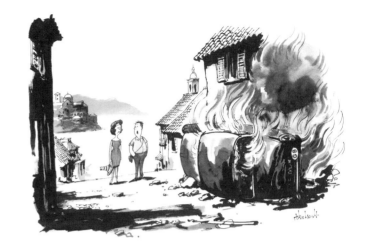

42 'Let me through. I'm a Doctor'
'Make way there. I'm a Doctor'
'Stand back please. I'm a Doctor'
signed and inscribed with title
pen and ink with monochrome watercolour and crayon
6 ½ x 11 ¾ inches
Illustrated: *Punch*, 14 September 1966, pages 406-407

"LET ME THROUGH . I'M A DOCTOR" "MAKE WAY THERE . I'M A DOCTOR" "STAND BACK PLEASE . I'M A DOCTOR"

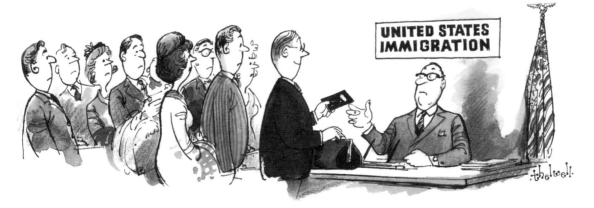

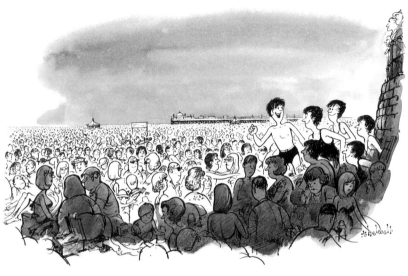

43 Right. Last one in is a sissy!
signed and inscribed with title
pen ink and monochrome watercolour with crayon
7 ½ x 11 inches
Illustrated: *Punch*, 1 June 1966, page 791;
Norman Thelwell, *The Effluent Society*, London:
Methuen, 1971, page 37

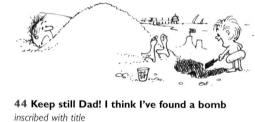

44 Keep still Dad! I think I've found a bomb
inscribed with title
pen and ink
2 ½ x 4 ¾ inches

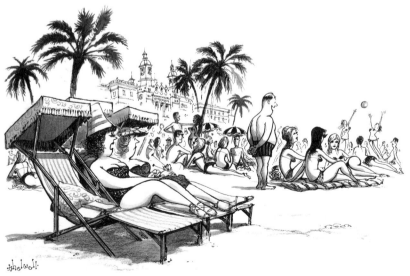

**45 Alfred supports Mr Wilson's Policy in Europe
– he won't take *no* for an answer**
signed
inscribed with title below mount
pen ink and monochrome watercolour with pencil
8 x 11 ½ inches
Illustrated: *Punch*, 19 July 1967, page 97

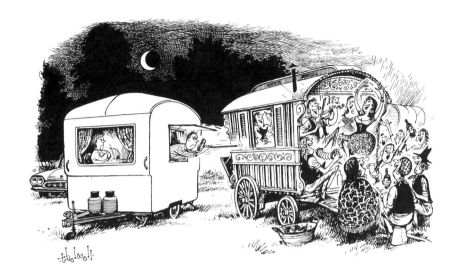

46 Noisy Neighbours
signed
pen and ink
6 x 10 inches
Illustrated: *Sunday Express*,
7 May 1967, page 21

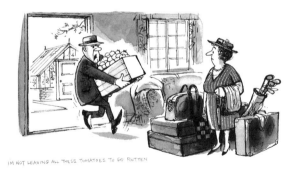

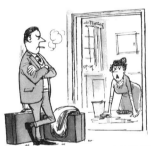

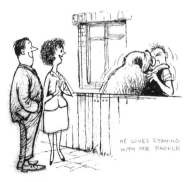

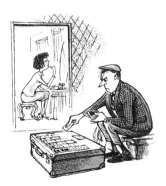

47 Packed and Ready
'I'm not leaving all these tomatoes
to go rotten'
'Suppose there was a fire and
someone came in'
'He loves staying with Mr Parker'
inscribed with title
pen ink and monochrome watercolour
with crayon
8 ½ x 12 inches

4: MOTORING

48 Punch Goes Outdoors
signed
inscribed 'Goes Outdoors' below mount
watercolour with pen ink, bodycolour and crayon
11 x 9 inches
Illustrated: *Punch,* summer number, 16 June 1971, front cover

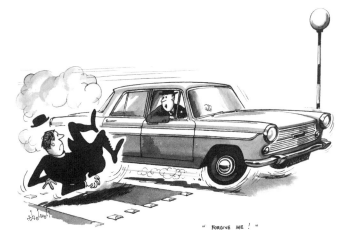

49 Morning Rush-Hour
signed
pen and ink
9 ½ x 9 ½ inches

50 Forgive Me!
signed and inscribed with title
pen ink and monochrome watercolour
7 ½ x 10 ½ inches

51 And now we've got a slow puncture
signed
inscribed with title below mount
pen ink and monochrome watercolour
9 ¼ x 11 ¾ inches
Illustrated: *Punch*, 16 November 1960,
page 705;
Norman Thelwell, *Thelwell in Orbit*,
London: Methuen, 1961, page 26

**52 Crash! Wallop! Bang! Every
time we get a bit of fog**
signed
inscribed with title below mount
pen ink and monochrome watercolour
6 ½ x 10 inches
Illustrated: *Punch*, 8 January 1969,
page 51

**53 The AA Man and the
Holiday Queues**
signed
pen and ink
7 ½ x 10 ¾ inches
Illustrated: *Punch*, 1 June 1960,
page 749; Norman Thelwell,
Thelwell in Orbit, London: Methuen,
1961, page 21; Russell Brockbank
[editor], *Motoring Through Punch*,
Newton Abbot: David & Charles,
1970, page 105

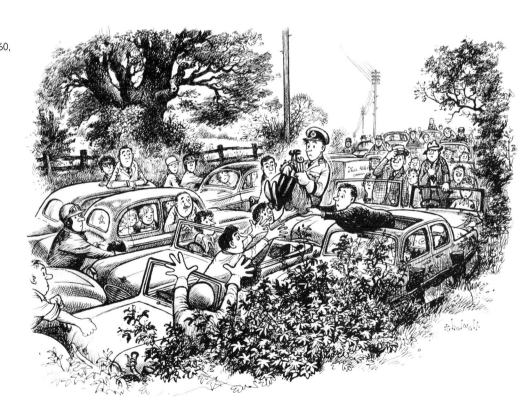

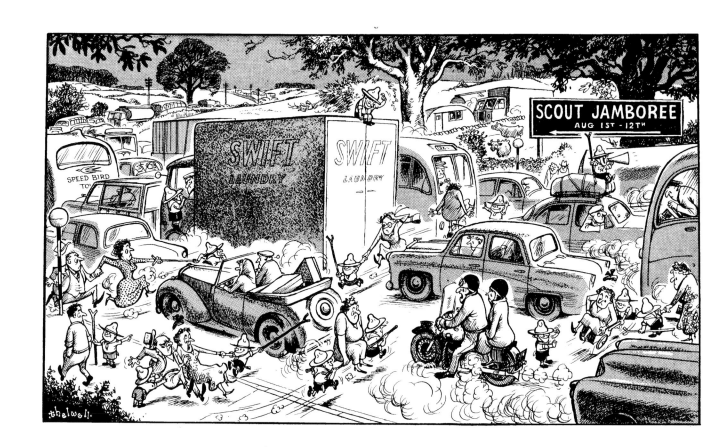

54 These chaps must be the only people in the country who are happy about the British roads! ...
signed
inscribed with title below mount
pen and ink with zippatone and bodycolour
10 ½ x 15 inches

55 Don't get too far ahead
signed and inscribed with title
pen ink and watercolour with bodycolour
12 x 9 ¾ inches
Illustrated: *Punch*, 18 September 1963, page 419

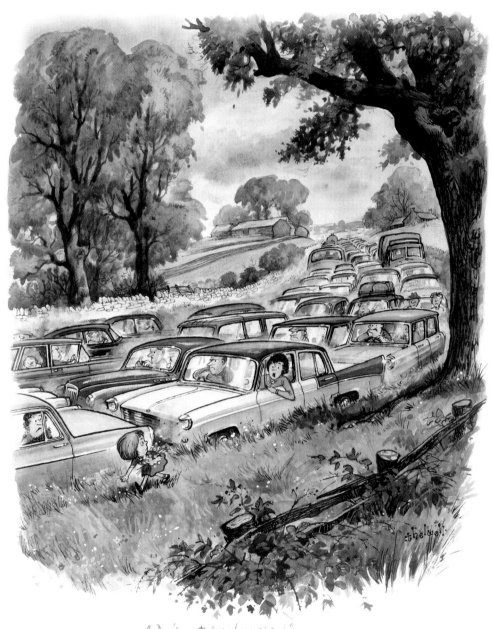

"Don't get too far ahead"

56 A Previous Year's Model
signed
pen ink and monochrome watercolour
7 ½ x 10 inches
Illustrated: *Punch*, 6 December 1967, page 848;
Norman Thelwell, *The Effluent Society*, London:
Methuen, 1971, page 31

57 Your dinner's in the oven
signed
inscribed with title below mount
pen ink and monochrome watercolour with crayon
6 ½ x 10 ½ inches
Illustrated: *Punch*, 16 June 1965, page 907;
Norman Thelwell, *Thelwell's Book of Leisure*, London: Methuen, 1968, page 20

5: FARMING

58 Feather Bed Farmer
signed
inscribed with title below mount
pen ink and watercolour
with bodycolour
8 x 12 inches
Illustrated: *Punch*, 24 December 1958, page 813

59 Christmas Poultry
signed
pen ink and coloured pencil
6 ½ x 10 ½ inches
Preliminary drawing for *Punch*, 24 December 1958, page 813

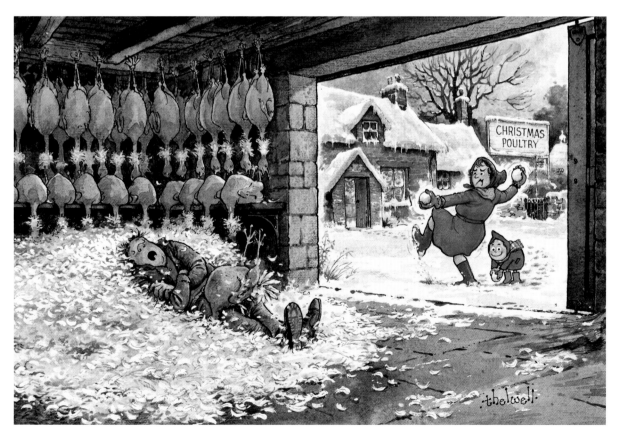

60 It looks as if we'll have all the weather in Europe to worry about soon
inscribed with title
pen ink and monochrome watercolour with crayon
8 x 10 ½ inches
Illustrated: *Punch*, 5 July 1961, page 5

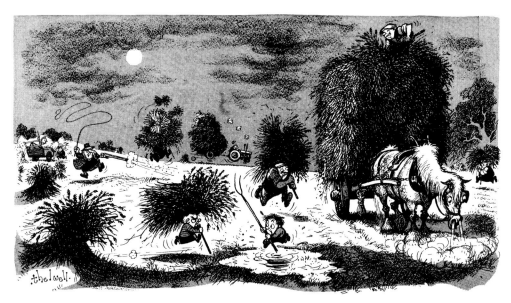

61 Here's one kid who'll be blooming glad to get back to school on Monday
signed
inscribed with title below mount
pen ink and zippatone with crayon
7 ½ x 12 inches

62 Christmas is Coming
'Didn't you keep back one for us?'
'Suppose we all decided to take one home for the children – then what?'
inscribed with title and captions
pen ink and watercolour with crayon and pencil
13 ¾ x 7 inches
Illustrated: *Punch*, 9 December 1964, page 880

63 Christmas with Mr Punch
signed
watercolour and bodycolour with pen and ink
11 ¼ x 8 ½ inches
Preliminary sketch for *Punch*, 14 December 1960, front cover

64 I've heard he's making a fortune
signed and inscribed with title
pen and ink
7 x 9 inches
Illustrated: *Sunday Express*,
13 November 1966, page 26

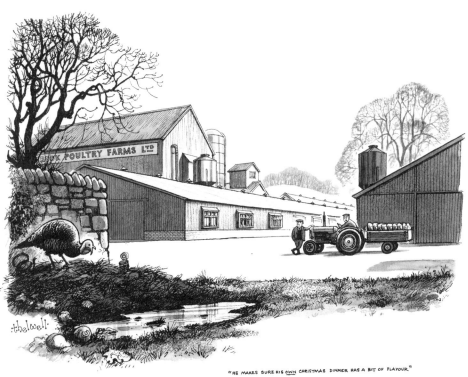

"HE MAKES SURE HIS OWN CHRISTMAS DINNER HAS A BIT OF FLAVOUR."

65 He makes sure his *own* Christmas dinner has a bit of flavour
signed and inscribed with title
pen ink, monochrome watercolour and crayon with pencil
8 ½ x 11 inches
Illustrated: *Punch*, 12 December 1962, page 850;
Norman Thelwell, *The Effluent Society*, London: Methuen, 1971, page 43;
Tatler & Bystander, December 1971, page 79

6: GARDENING

66 Mrs 'Opkins! Did your kids give you a perishing great bunch of daffodils for Mother's Day?
signed and inscribed with title
pen ink and zippatone with crayon
and bodycolour
7 ¼ x 12 inches

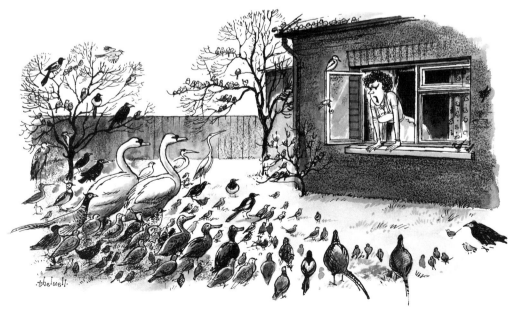

67 The big freeze is over
signed
inscribed with title and 'Winter's over!' below mount
pen, ink, watercolour and crayon
7 ½ x 12 inches
Illustrated: *Punch*, 13 March 1963, Page 363;
Norman Thelwell, *The Effluent Society*, London: Methuen, 1971, page 63, as 'Winter's over!'

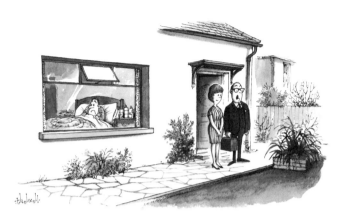

68 Cut them out and transplant them. That's my advice
signed and inscribed with title
pen ink and monochrome watercolour with crayon
7 ¾ x 12 inches
Illustrated: *Punch*, 1 January 1969, page 9;
Norman Thelwell, *The Effluent Society*, London: Methuen, 1971, page 67

69 … And the things you called the neighbour's children when they pinched a few!
signed
inscribed with title below mount
pen ink and monochrome watercolour
with crayon
9 x 10 ½ inches
Illustrated: *Punch*, 24 October 1962,
page 599

70 I've changed my mind. The sooner they start nibbling at the green belt round here the better
signed and inscribed with title
pen ink and monochrome watercolour
9 ¼ x 12 inches
Illustrated: *Punch*, 29 May 1963, page 786

Nos **71-75** are all unused drawings for the cartoon feature, 'Plant a tree in '73 ... and Thelwell chops down a few illusions', *Punch*, 14 March 1973, pages 358-359

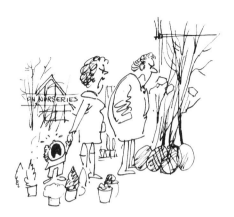

71 For goodness sake, get him a conker tree!
inscribed with title
pen and ink
3 ¾ x 7 ½ inches

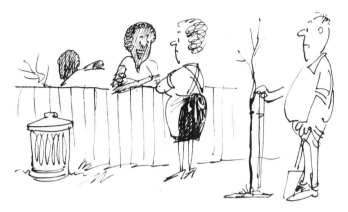

72 Bert's planting Yams & Pau Pau
inscribed with title
pen and ink
3 ½ x 5 ½ inches

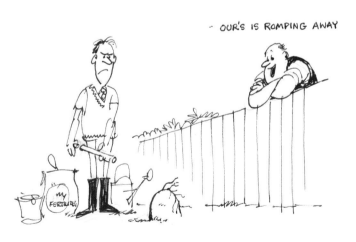

73 – Our's is romping away –
inscribed with title
pen and ink
3 ⅓ x 5 ½ inches

74 You're too impatient. They take a hundred years to mature
inscribed with title
pen and ink
5 x 6 inches

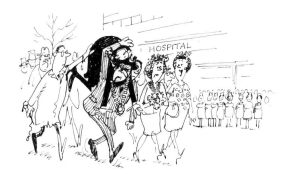

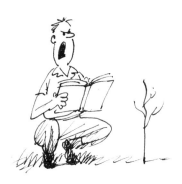

75 It's lucky his back gave out while he was planting one here
inscribed with title
pen and ink
4 ½ x 6 ½ inches

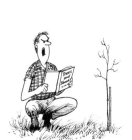

" Ethel ! It's got Dutch Elm Disease.."

" We'll have to clear a bit of ground -"

76 Ethel! It's got Dutch Elm Disease
inscribed with title
pen and ink
2 ¾ x 5 inches
Preliminary drawing for *Punch*, 14 March 1973, page 358, 'Plant a tree in '73 ... and Thelwell chops down a few illusions'

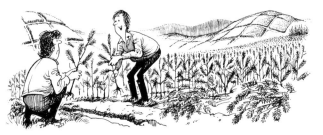

" I think I'll put an extra one in during my lunch break. "

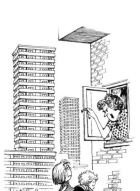

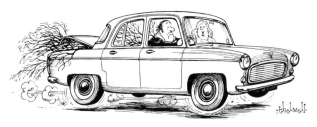

" Clear off with your acorns —
You'll undermine the foundations"

" Nicking them from Epping Forest defeats the whole object -"

77 'Ethel! It's got Dutch Elm Disease.'
'Clear off with your acorns – you'll undermine the foundations'
'We'll have to clear a bit of ground'
'I think I'll put an extra one in during my lunch break'
'Nicking them from Epping Forest defeats the whole object'
pen and ink
13 x 13 ½ inches
Illustrated: *Punch*, 14 March 1973, pages 358-359, 'Plant a tree in '73 ... and Thelwell chops down a few illusions'

7: SCIENCE AND INDUSTRY

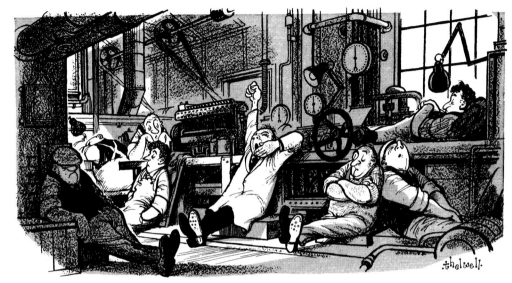

78 Let's have a lightning strike
signed and inscribed with title
pen and ink with zippatone and crayon
7 x 12 inches

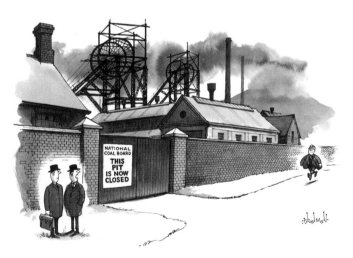

79 Hello! Here comes another habitual absentee
signed and inscribed with title
pen ink and monochrome watercolour
7 ¾ x 10 ½ inches
Illustrated: *Punch*, 14 February 1968, page 219

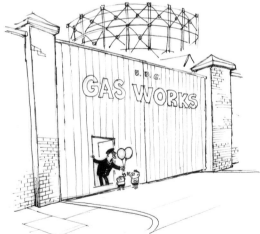

80 There you are – now beat it!
inscribed with title
pen and ink
7 x 7 inches

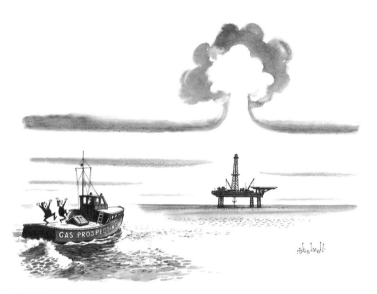

81 It's a gusher!
signed and inscribed with title
pen ink and monochrome watercolour with pencil
9 x 11 inches
Illustrated: *Punch*, 16 August 1967, page 242

82 Any jobs going, mate?
inscribed with title
pen and ink with pencil
7 ½ x 4 ½ inches
Preliminary drawing for *Punch*, 3 April
1974, page 556, 'How to stay rich
though British'

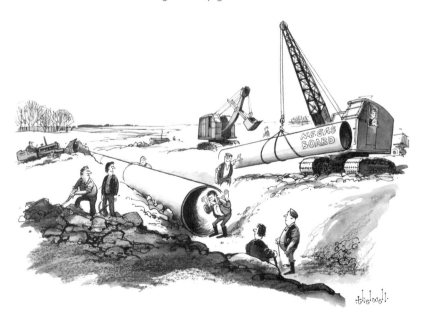

83 Quiet, it's Charlie. They've made another gas strike
signed and inscribed with title
pen ink and monochrome watercolour with crayon
9 ¼ x 12 inches
Illustrated: *Punch*, 8 February 1967, page 197;
Norman Thelwell, *The Effluent Society*, London:
Methuen, 1971, page 72

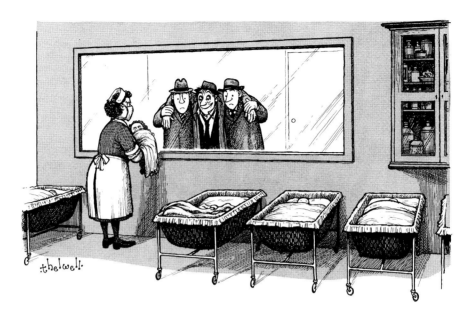

84 The New Father
signed
pen ink and zippatone
6 ¾ x 10 ¼ inches
Illustrated: *Punch*, 6 January 1960,
page 55

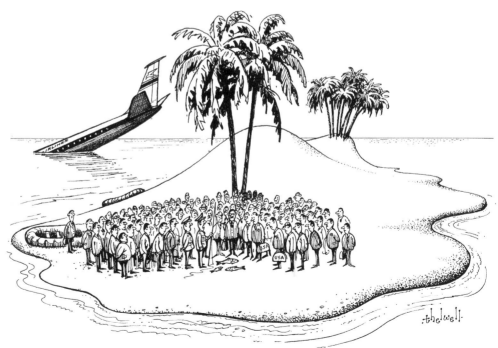

**85 Twenty-three Doctors,
thirty-eight Scientists and
forty-one Technologists.
Can't anyone cook?**
signed and inscribed with title
pen and ink
9 ¼ x 12 inches
Illustrated: *Punch*, 15 November
1967, page 739

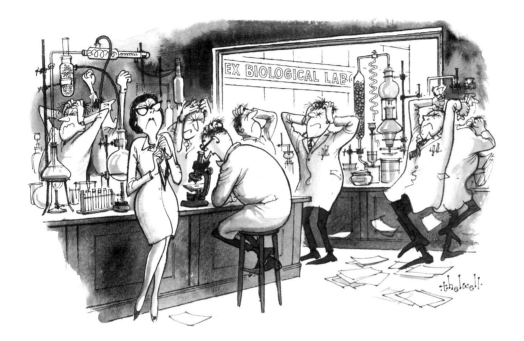

86 No! No! She fended him off again ... now he's gone to sleep
signed and inscribed with title
pen ink and monochrome watercolour
with crayon
8 x 12 inches
Illustrated: *Punch*, 23 October
1968, page 580;
Norman Thelwell, *The Effluent Society*, London: Methuen, 1971,
page 60

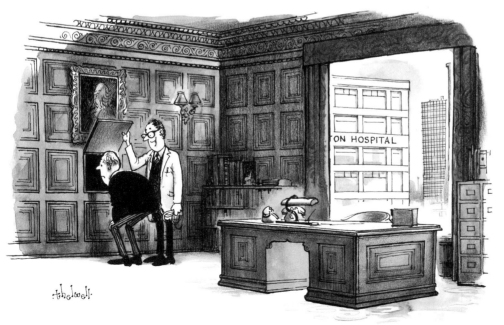

87 Don't let on to the kitchen staff. It's where we hide the private patients
signed
inscribed with title below mount
pen and ink with monochrome
watercolour, crayon and pencil
5 ¼ x 9 inches
Illustrated: *Punch*, 15 October
1975, page 651

8: HUNTING

88 Door!
signed and inscribed twice with title
pen ink and monochrome watercolour
8 x 10 inches
Illustrated: *Punch*, 15 December 1971, page 829;
Norman Thelwell, *Wrestling with a Pencil*, London: Methuen, 1986,
page 87

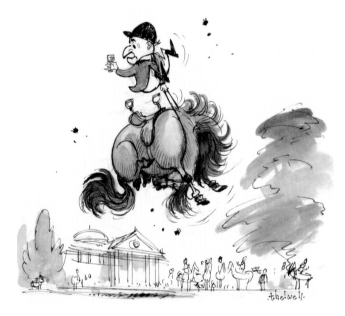

90 Punch at the Hunt
signed
pen ink and monochrome watercolour with pencil
10 x 8 inches

89 Student Demonstrators
signed
pen ink and monochrome watercolour with crayon
7 x 9 inches
Illustrated: *Punch*, 22 July 1970, page 134;
Norman Thelwell, *The Effluent Society*, London: Methuen, 1971, page 88

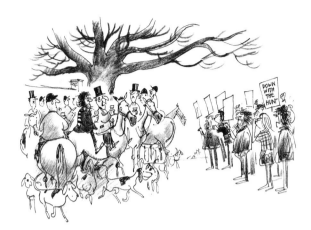

91 He's asked for political asylum
inscribed with title
pen ink and pencil
7 x 9 inches
Preliminary drawing for Norman Thelwell,
Some damned fool's signed the Rubens again,
London: Methuen, 1982, page 58

92 He's asked for political asylum
signed and inscribed with title
inscribed with title below mount
pen and ink with monochrome watercolour
Illustrated: Norman Thelwell, *Some
damned fool's signed the Rubens again,*
London: Methuen, 1982, page 58

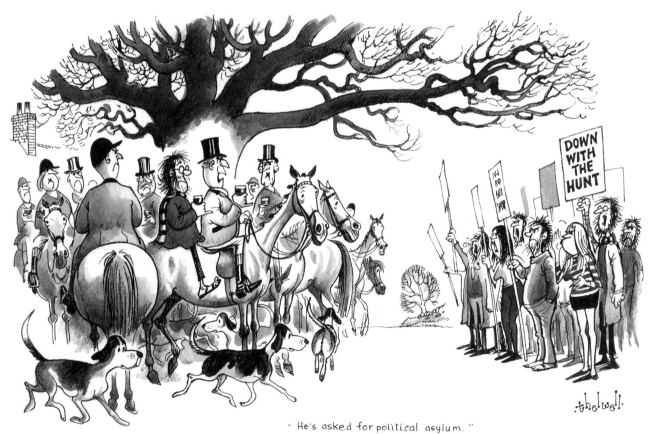

" He's asked for political asylum. "

93 Keeping a Good Stable by Thelwell
They don't breed horses like that any more
signed
inscribed with subtitle
below mount
pen ink and monochrome
watercolour with crayon
10 ½ x 9 inches
Illustrated: *Tatler*,
February 1973, page 31

**94 Trials of True Love
by Thelwell**
I don't think we should go on
meeting like this, Mervyn. Daddy's
beginning to get suspicious
*signed and inscribed with subtitle
pen ink and monochrome watercolour
with crayon*
11 ½ x 8 ½ inches
Illustrated: *Tatler*, December 1973,
page 43

9: RIDING

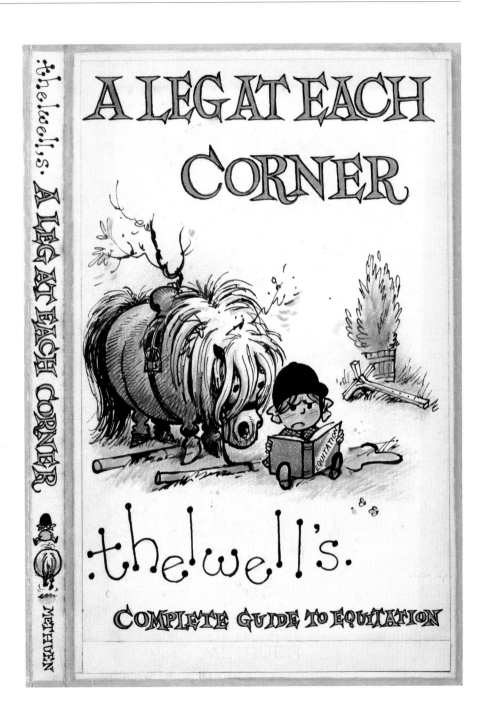

95 A Leg at Each Corner
pen and ink with watercolour and crayon
7 ½ x 5 ¼ inches
Preliminary design for Norman Thelwell,
A Leg at Each Corner. Thelwell's Complete
Guide to Equitation, London: Methuen,
1962, dust jacket

96 Tally Ho!
signed with initial 't'
pen and ink
3 ¼ x 5 ½ inches

97 Jump!
signed with initial 't'
pen and ink
3 ¼ x 5 ½ inches

Similar to Norman Thelwell, *A Leg at Each Corner. Thelwell's Complete Guide to Equitation*, London: Methuen, 1962, page 86

98 Through The Wall
signed with initial 't'
pen and ink
3 ¼ x 5 ½ inches

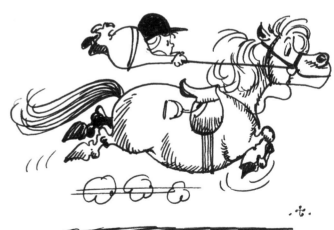

99 At a Gallop
signed with initial 't'
pen and ink
3 ¼ x 4 ½ inches

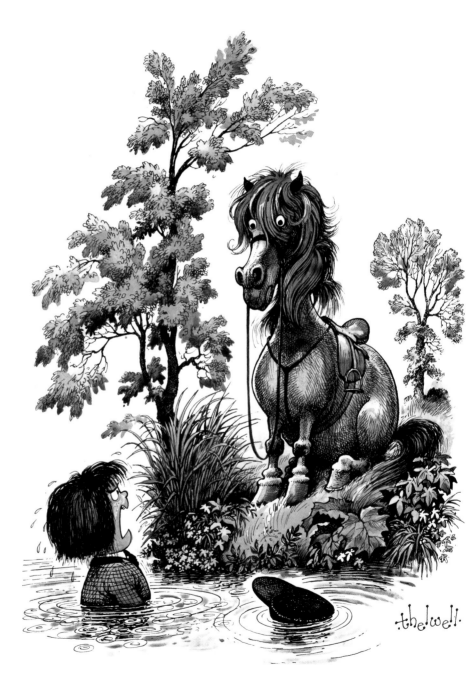

100 Talk to your pony – he will know what you mean
signed
pen ink and watercolour
14 x 9 inches
Similar to Norman Thelwell, *A Leg at Each Corner. Thelwell's Complete Guide to Equitation*, London: Methuen,1962, page 27;
Norman Thelwell, *Thelwell's Pony Birthday Book*, London: Methuen, 1979, for 1 September;
Norman Thelwell's Horse Sense, London: Methuen, 1980 [unpaginated]

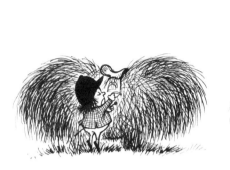 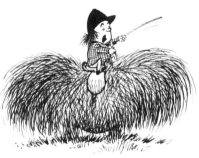 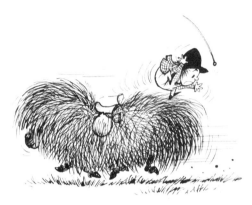

NEGLECTING YOUR PONY'S COAT IS A SERIOUS MATTER.

... WHICH CANNOT FAIL ...

... TO CAUSE TROUBLE

101 Neglecting your pony's coat is a serious matter ... which cannot fail ... to cause trouble
inscribed with title
pen and ink
4 ½ x 14 ½ inches

Illustrated: *Sunday Express*, 12 January 1964, page 20;
Norman Thelwell, *Thelwell's Riding Academy*, London: Methuen, 1969, pages 58-59;
Norman Thelwell, *Thelwell's Pony Birthday Book*, London: Methuen, 1979 for 18-21 October

102 Your pony's shoes should be checked regularly
inscribed with title
pen and ink
3 x 4 ½ inches
Illustrated: *Sunday Express*,
23 February 1964

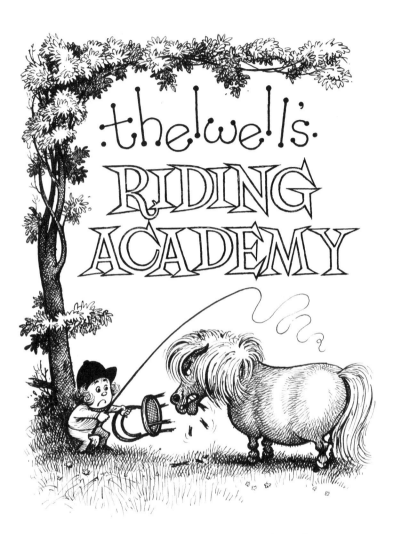

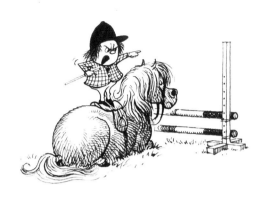

NEVER SPEAK ANGRILY TO YOUR PONY

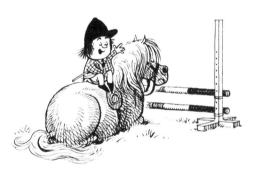

USE A KIND, GENTLE VOICE

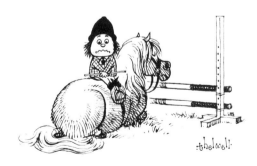

IT WILL BE JUST AS EFFECTIVE

103 Thelwell's Riding Academy
pen and ink
8 ¼ x 6 inches
Illustrated: Norman Thelwell,
Thelwell's Riding Academy, London:
Methuen, 1965, dust jacket
(published with colour background)

104 Never speak angrily to your pony
Use a kind, gentle voice
It will be just as effective
signed and inscribed with title
pen and ink
14 x 5 inches
Illustrated: *Sunday Express*, 19 January 1964, page 20;
Norman Thelwell, *Thelwell's Riding Academy*,
London: Methuen, 1965, pages 26-27;
Norman Thelwell, *Thelwell's Pony Birthday Book*,
London: Methuen, 1979, for 28-29 February

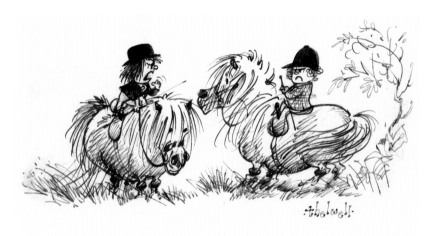

105 I've broken more collar bones than you've had hot dinners
signed, inscribed with title and 'With Best Wishes from Norman Thelwell', and dated 1970
pen and ink
5 ½ x 7 inches

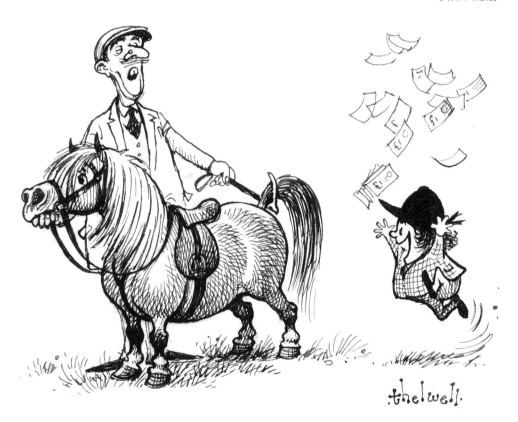

106 The New Pony
signed
pen and ink
4 x 5 ½ inches

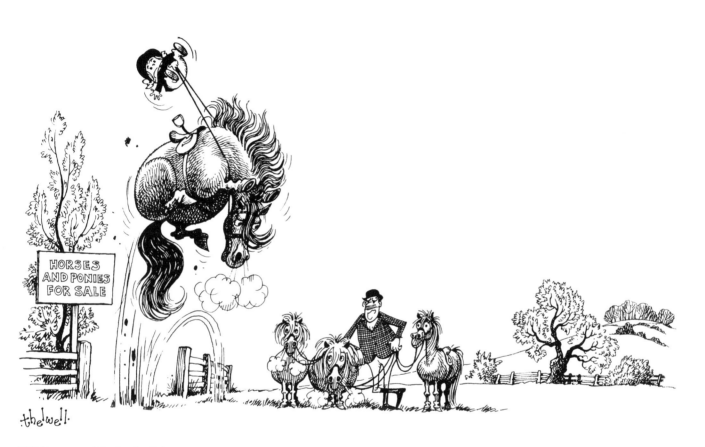

107 Horses and Ponies for Sale
signed
pen and ink
7 x 12 inches

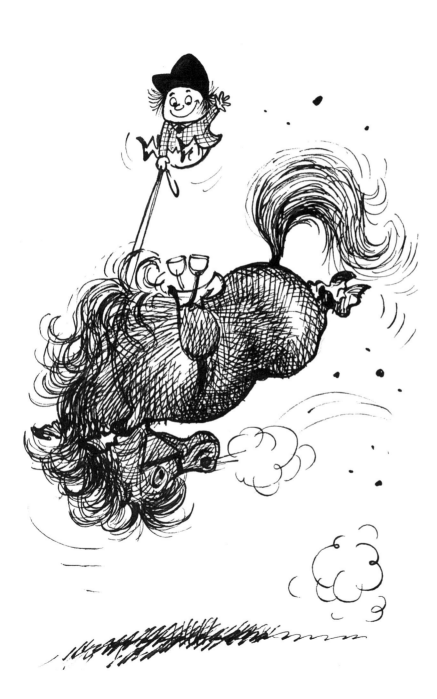

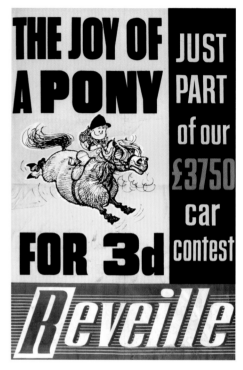

108 The Joy of a Pony ...
printed paper
29 x 19 ½ inches

**109 For speedy operation and ease of control
– get a pony**
inscribed with title
inscribed 'Our pony also throws one a minute' on reverse
pen and ink
8 x 4 inches

**110 Keeping a Good Seat
by Thelwell**
I blame the Jockey Club for
admitting women to the sport
signed and inscribed
with subtitle
pen ink and monochrome
watercolour
12 x 10 inches
Illustrated: *Tatler*, November
1972, page 29

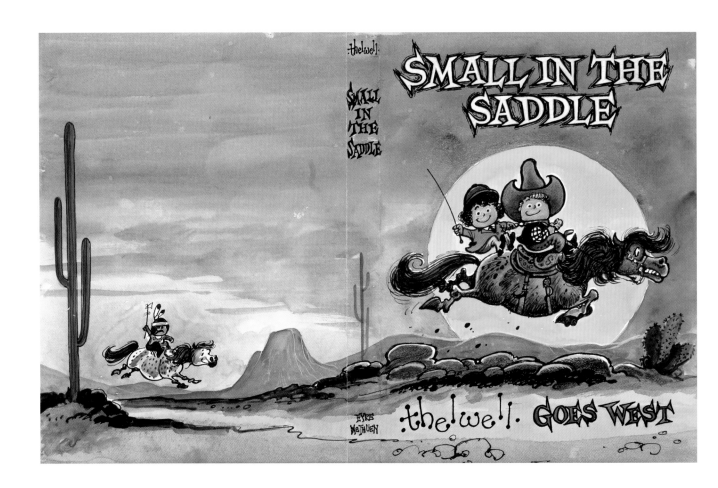

111 Small in the Saddle
Thelwell goes West
pen ink and watercolour with bodycolour and crayon
8 ¼ x 14 ¾ inches
Preliminary design for Norman Thelwell, *Thelwell Goes West*, London:
Methuen, 1975, dust jacket

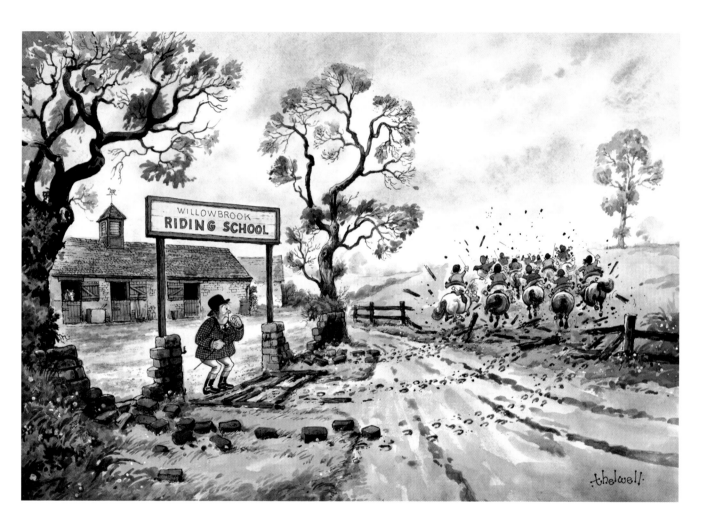

112 Willowbrook Riding School
signed
watercolour and bodycolour with pen and ink
11 x 16 inches
Similar to *Punch*, 9 May 1956;
Norman Thelwell, *Angels on Horseback*, London: Methuen, 1957, page 40

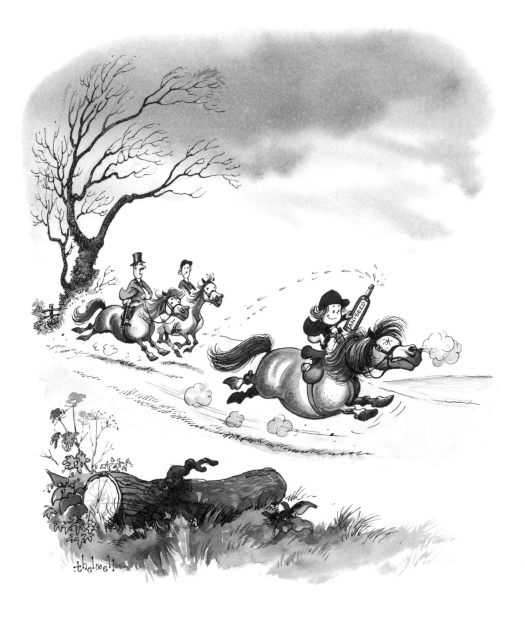

" You mark my words, Mildred, we're going to have trouble with that girl when she grows up. "

113 Thelwell in the Hunting Field
You mark my words, Mildred, we're going to have trouble with that girl when she grows up
signed and inscribed with subtitle
pen ink and monochrome watercolour with pencil
11 ½ x 9 inches
Illustrated: *Tatler*, January 1973, page 37

114-122 are all pencil

114 Brushing Down
3 ¼ x 2 ½ inches

115 Skipping
3 ¼ x 2 ¼ inches

116 Well Balanced
3 ¼ x 2 inches

117 The Joy of Riding
3 ¼ x 2 ¼ inches

118 False Start
3 ¼ x 2 inches

119 Sitting Pretty
3 ¼ x 2 inches

120 Water Jump
3 ¼ x 2 inches

121 Learner
3 ½ x 1 ¾ inches

122 Stubborn as a Mule
3 ¼ x 2 ¼ inches

114

115

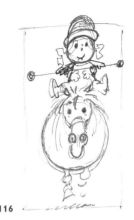

116

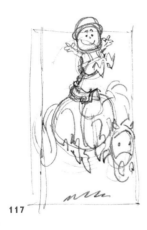

117

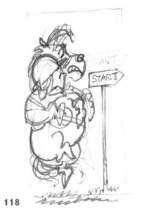

118

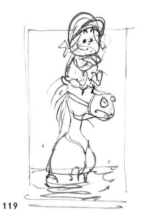

119

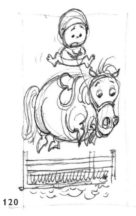

120

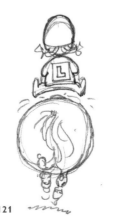

121

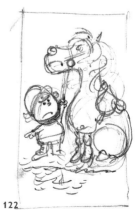

122

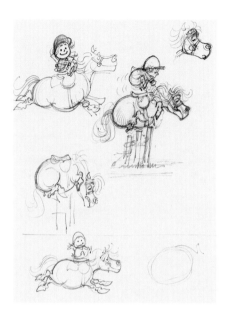

123 The Jump
pencil
9 x 6 ½ inches

124 For the last time! I will *not* have him inside this house until you've done your homework
signed and inscribed with title
pen and ink
4 ¾ x 7 ¼ inches
Illustrated: *Punch*, 7 November 1973, page 660,
'The Thatched Living Room'

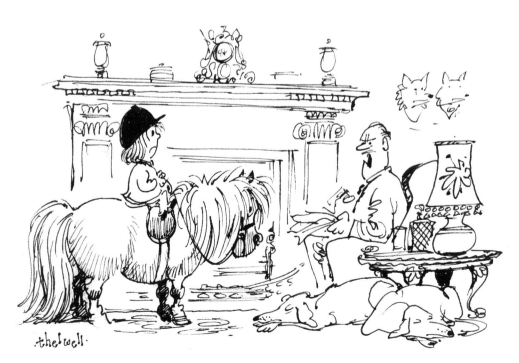

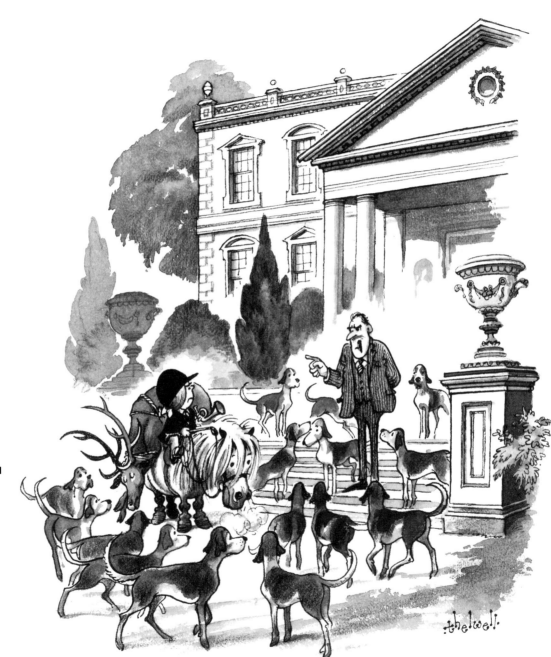

125 Trials of Parenthood by Thelwell
How many times have I told you about hunting out of season?
signed and inscribed with subtitle
pen ink and monochrome watercolour
11 x 9 ½ inches
Illustrated: *Tatler*, July 1975, page 37;
Norman Thelwell, *Some Damned Fool's Signed the Rubens Again*, London: Methuen, 1982, page 55

10: FOOTBALL

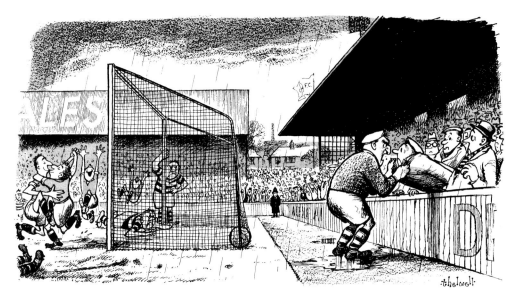

126 Come on! Which of you lot shouted 'He's been on strike all season'?
signed and inscribed with title
pen ink and zippatone
7 x 12 inches

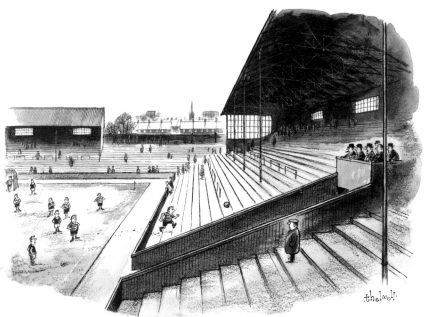

127 The drop in gates is getting serious
signed and inscribed with title
pen ink and watercolour with pencil
8 ½ x 11 inches
Illustrated: *Punch*, 31 January 1962, page 198

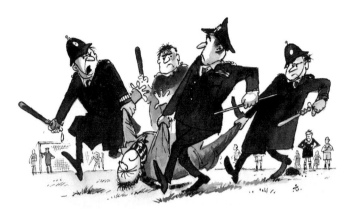

128 All the same – I agree with what he said to the Ref
signed with initial 't' and inscribed with title
pen ink and monochrome watercolour
4 ½ x 6 ¾ inches
Illustrated: *Punch*, 29 April 1964, page 635, 'Up for the Cup';
Norman Thelwell, *The Effluent Society*, London: Methuen, 1971, page 96

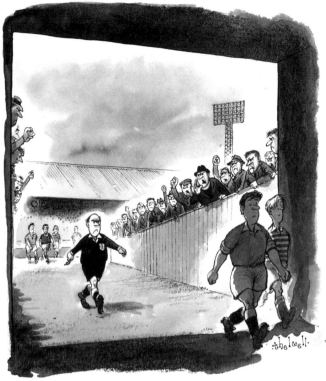

129 May heaven forgive you
signed
inscribed with title below mount
pen ink and monochrome watercolour
8 ½ x 7 ½ inches
Illustrated: *Punch*, 25 December 1963, page 934;
Norman Thelwell, *Thelwell's Book of Leisure*, London: Methuen, 1968, page 74

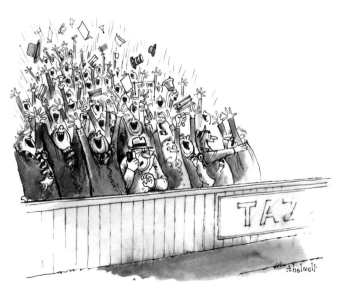

130 Ooooh! Greaves just missed a sitter at Highbury
signed
inscribed with title below mount
pen ink and monochrome watercolour
6 ¼ x 8 inches
Illustrated: *Punch*, 23 October 1963, page 615

132 Sex & violence! It's all we ever get
signed and inscribed with title
pen ink and monochrome watercolour
6 ½ x 7 ½ inches
Illustrated: *Punch*, 29 December 1965, page 976;
Norman Thelwell, *The Effluent Society*, London:
Methuen, 1971, page 85

131 '... And no kicking railway carriages in your best boots'
'You asked for it. Pulling the communication cord on the
way to the match'
'You look after injuries in the pubs. OK?'
inscribed with titles
pen ink and monochrome watercolour with crayon
three images measuring overall 13 ½ x 10 inches
Illustrated: *Punch*, 29 April 1964, page 634, 'Up for the Cup'

133 Running for safety
pen ink and monochrome watercolour
2 ¾ x 8 ½ inches
Illustrated: *Punch*, 29 April 1964,
pages 634-635, 'Up for the Cup'

134 'The Referee's word is final'
'It was a great victory' (below)
inscribed with titles
pen ink and monochrome watercolour
two images measuring overall 9 x 7 inches
Illustrated: *Punch*, 29 April 1964,
pages 635 and 634, 'Up for the Cup'

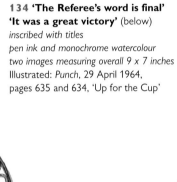

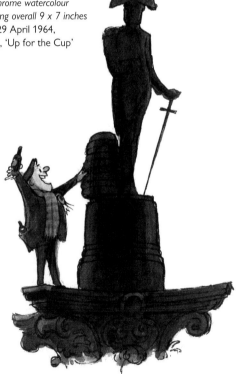

135 Own Goal
signed
pen and ink
4 ½ x 10 ½ inches

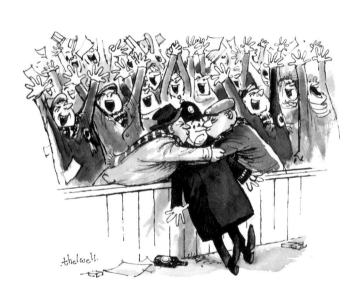

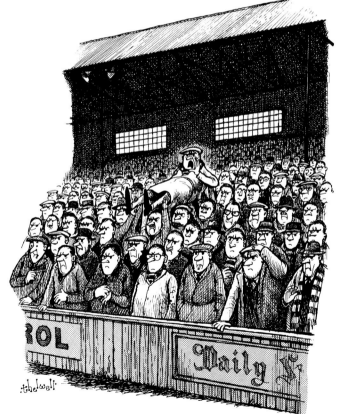

136 Enthusiasm
signed
pen ink and watercolour
4 ¾ x 6 ¼ inches

137 Get rid of it Man!
signed and inscribed with title
pen ink and zippatone
9 x 7 inches
Illustrated: *Punch*, 7 April 1965,
page 511

138 Call yourself a Supporter?
signed and inscribed with title
pen ink and monochrome watercolour with crayon
7 x 10 inches
Illustrated: *Punch*, 10 January 1968, page 53;
Norman Thelwell, *The Effluent Society*, London: Methuen,
1971, page 95

**139 He fought at Molineaux, White Hart Lane and
Roker Park. Then get wounded on Spion Cop**
signed and inscribed with title
pen ink and monochrome watercolour with crayon
6 x 7 ½ inches
Illustrated: *Punch*, 15 November 1967, page 735

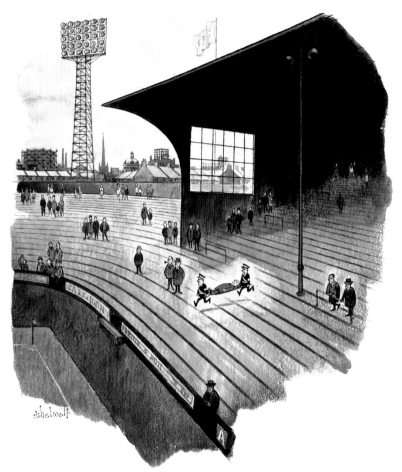

140 I can remember the days when we got them passed down to us
signed and inscribed with title
pen ink and watercolour with crayon
13 x 11 inches
Illustrated: *Punch*, 3 November 1965, page 652

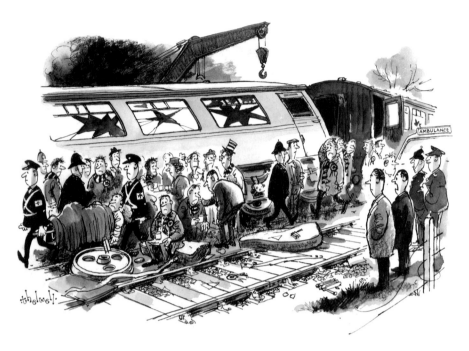

141 I understand it was caused by an off-side decision at White Hart Lane
signed and inscribed with title
pen ink and monochrome watercolour with crayon
8 ½ x 11 inches
Illustrated: *Punch*, 11 October 1967, page 547;
Norman Thelwell, *The Effluent Society*, London:
Methuen, 1971, page 94

142 He got sent off on purpose!
signed
inscribed with title below mount
pen ink and monochrome watercolour with crayon
7 ½ x 11 inches
Illustrated: *Punch*, 18 January 1967, page 89;
Norman Thelwell, *Thelwell's Book of Leisure*,
London: Methuen, page 75

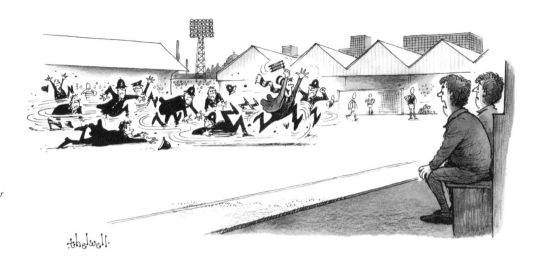

143 I wish we had a few mid-field players with *his* flair
signed
inscribed with title below mount
pen ink and monochrome watercolour with crayon
5 ½ x 10 inches
Illustrated: *Punch*, 31 October 1973, page 624

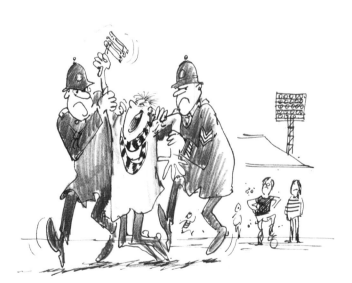

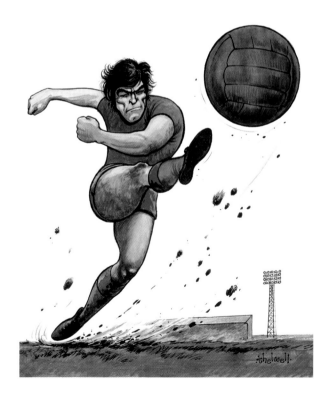

144 ... You'll ne ... ver ... walk ... a ... lone ...
inscribed with title
pen ink and pencil
5 ½ x 6 inches

145 The Truth About Football
signed
pen ink and watercolour with bodycolour and crayon
11 x 8 ¾ inches
Illustrated: *Punch,* 5 May 1971, front cover

11: ...AND OTHER SPORTS

146 A Number Four Iron
signed and inscribed with title
pen ink and monochrome watercolour with crayon
5 ½ x 10 ½ inches
Illustrated: *Punch*, 29 January 1969, page 155

147 The Office Golfer
signed
pen ink and monochrome watercolour
3 ½ x 10 ½ inches
Illustrated: *Punch*, 2 August 1967, page 163

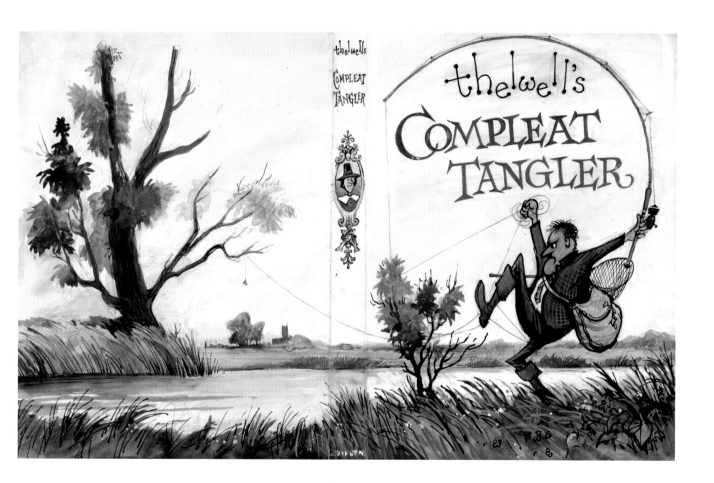

148 Thelwell's Compleat Tangler
watercolour and bodycolour with pencil
8 ¼ x 13 inches
Preliminary design for Norman Thelwell, *Thelwell's Complete Tangler.*
Being a Pictorial Discourse of Anglers and Angling, London: Methuen, 1967,
dust jacket

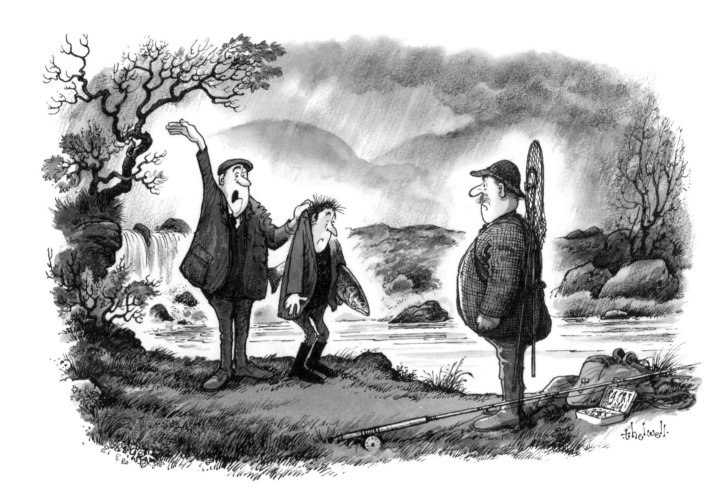

149 I caught an enormous one in Manor Pool, your Grace, but he got away
signed and inscribed with title
pen ink and monochrome watercolour with crayon
7 x 10 inches

150 A Tall Story by Thelwell
I caught an enormous one in Manor Pool, your Grace, but he got away
signed
inscribed with subtitle below mount
pen ink and monochrome watercolour
9 ½ x 7 ½ inches
Illustrated: *Tatler*, January 1974, page 41

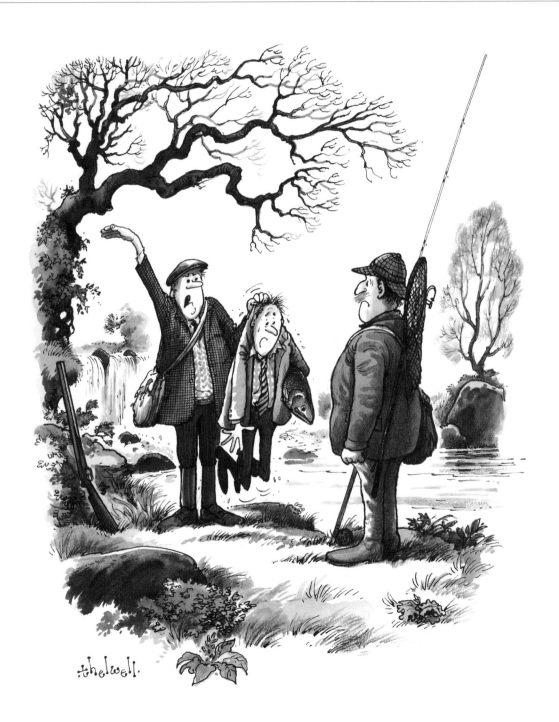

151 The Short-Sighted Shooter
signed and faintly inscribed 'Punch'
pen ink, crayon and bodycolour
10 x 7 ½ inches
Preliminary design for *Punch* front cover

152 Sport for the Hell of It
signed
pen ink and watercolour with bodycolour
14 ½ x 11 ¼ inches
Illustrated: *Punch*, summer number, 14 June 1972, front cover

153 My God, Arthur, we're not going to make it
signed
pen ink and monochrome watercolour with pencil
7 ¾ x 10 inches
Illustrated: *Punch*, 16 June 1971, page 795

154 Coastal Patrol
signed
inscribed with title below mount
watercolour with bodycolour, pen and ink
8 x 12 inches

12: GREETINGS CARDS AND SPORTING PRINTS

155 Self Service
signed
pen ink and coloured pencil
6 ½ x 10 ½ inches

156 Self Service
Merry Christmas
signed
pen ink and watercolour
8 x 12 inches

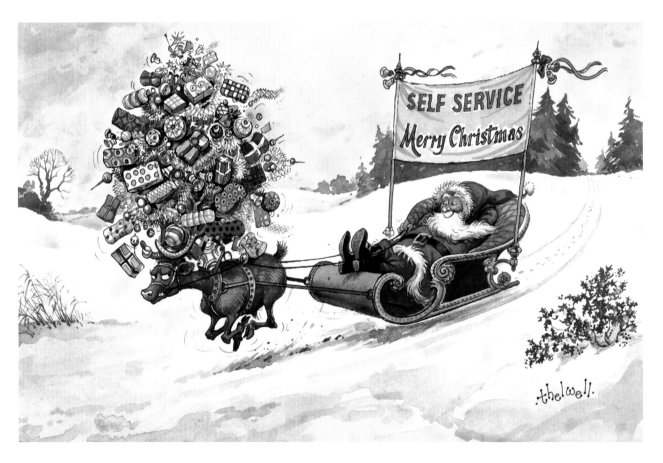

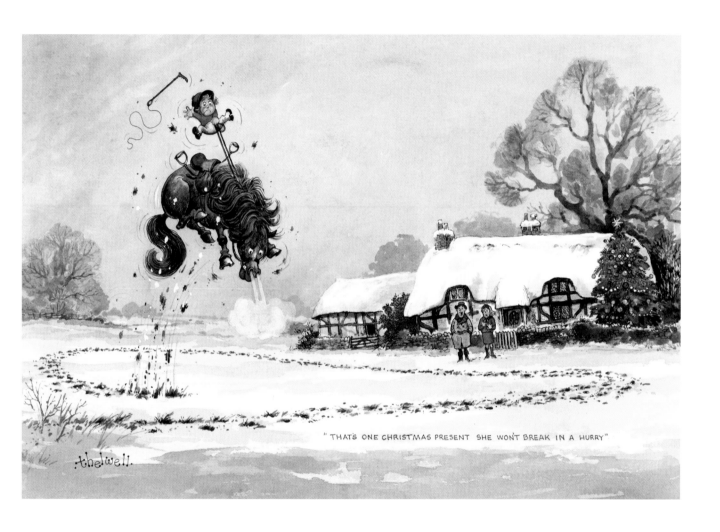

"THAT'S ONE CHRISTMAS PRESENT SHE WON'T BREAK IN A HURRY"

157 That's one Christmas present she won't break in a hurry
signed and inscribed with title
pen ink and watercolour with bodycolour
11 x 16 inches

A reworking of *Punch*, 14 January 1959, page 96, which was also published in Norman Thelwell, *Thelwell Country*, London: Methuen, 1959, page 8;
Norman Thelwell, *Drawing Ponies*, London: Studio Vista, page 6;
Norman Thelwell, *Thelwell's Pony Birthday Book*, London: Methuen, 1979, for December 24-25;
Norman Thelwell, *How to Draw Ponies. All the Secrets Revealed by Thelwell*, London: Methuen, 1982, page 6

158 The Perfect Present
signed
inscribed with title below mount
pen ink and watercolour with pencil
8 x 12 inches
Design for a greetings card for Royle

159 Gone Away
signed
inscribed with title below mount
pen ink and watercolour with bodycolour
8 x 12 inches
Illustrated: Norman Thelwell, *Thelwell's Sporting Prints*, London: Methuen, 1984, [unpaginated]

160 Postman Chased by Dogs
pencil
8 ¼ x 11 ½ inches
pencil sketch of dogs on reverse
Preliminary sketch for Norman Thelwell, *Thelwell's Sporting Prints*, London: Methuen, 1984, 'Gone Away'

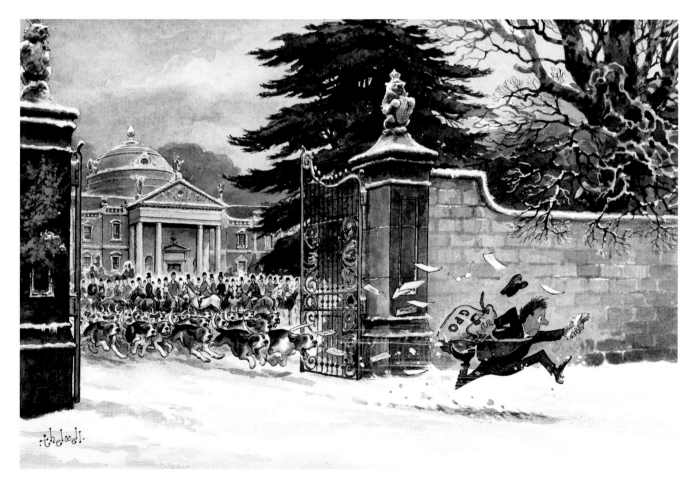

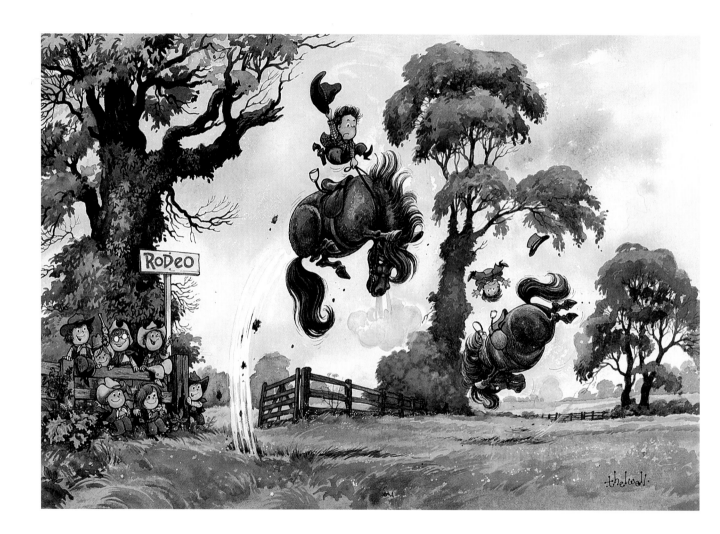

161 Rodeo
signed
watercolour and bodycolour with pen and ink
13 x 18 ¼ inches
Published in a series of Sporting Prints, 1973

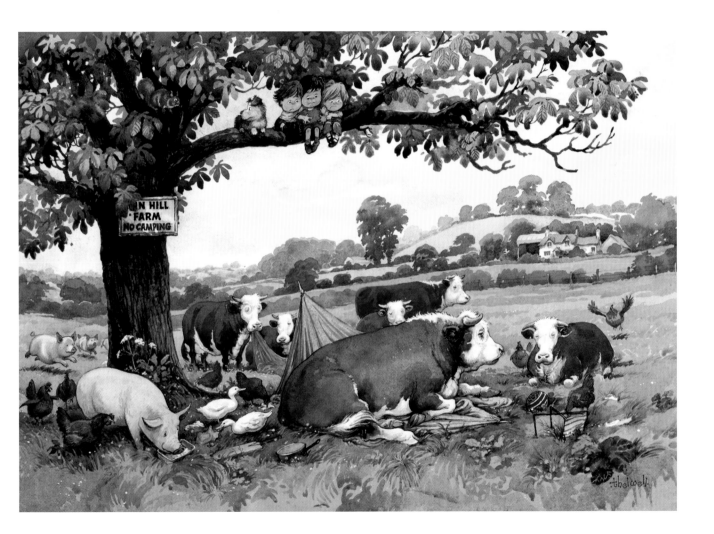

162 No Camping
signed
watercolour with pen ink, bodycolour and pencil
13 x 18 ¼ inches

163 Tote Double

inscribed with title below mount
watercolour with bodycolour
5 x 6 inches
Illustrated: Norman Thelwell, *Thelwell's Sporting Prints*,
London: Methuen, 1984, [unpaginated]

164 Tote Double (or Two to One On)

signed
inscribed with title below mount
watercolour with bodycolour
8 x 12 inches
Published in a series of Sporting Prints, 1978
Illustrated: Norman Thelwell, *Thelwell's Sporting Prints*,
London: Methuen, 1984, [unpaginated]

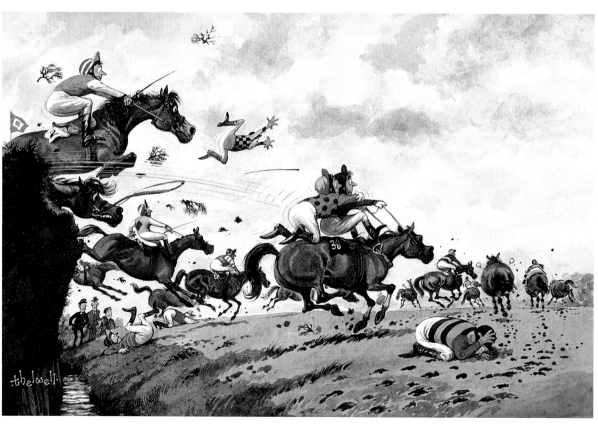

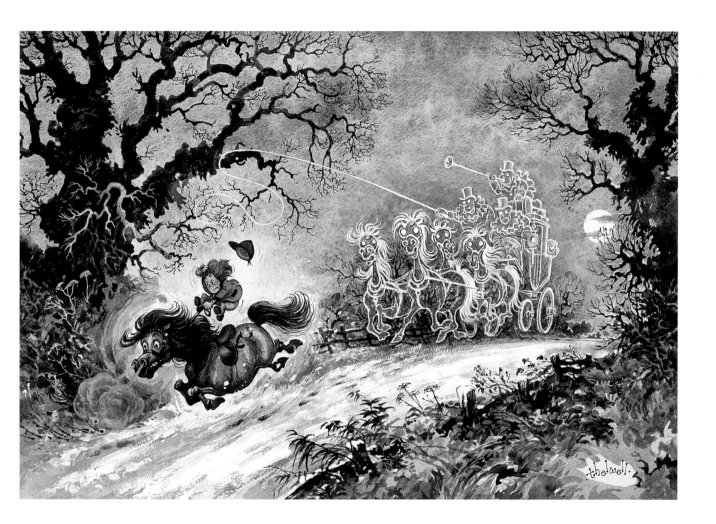

165 Phantom Stagecoach
signed
watercolour and bodycolour with pen and ink
11 x 16 inches
Published in a series of Sporting Prints, 1989

13: LANDSCAPES AND SEASCAPES

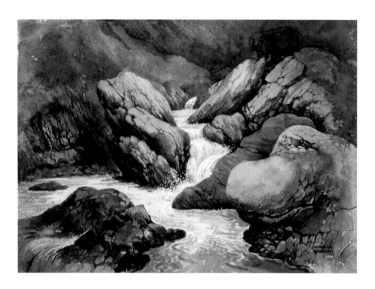

166 A Stream in the Elan Valley
signed
inscribed with title and dated 1972 on reverse
watercolour with bodycolour
7 ¼ x 10 inches

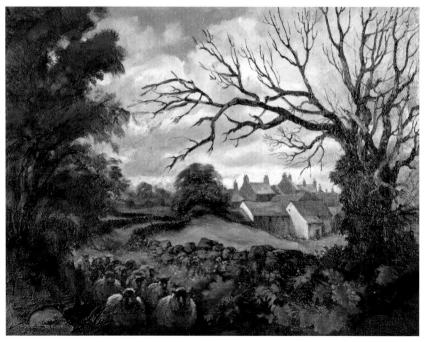

167 Landscape with Sheep
signed
oil on board
13 ¾ x 18 inches

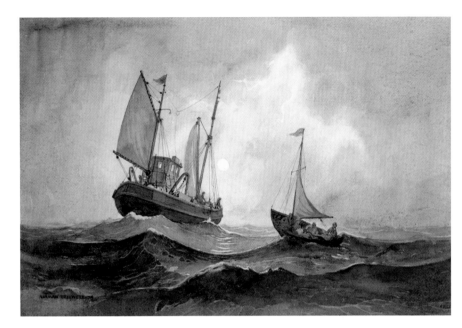

168 Boats on the Sea
signed and dated 74
watercolour with bodycolour and pencil
10 x 14 ¾ inches

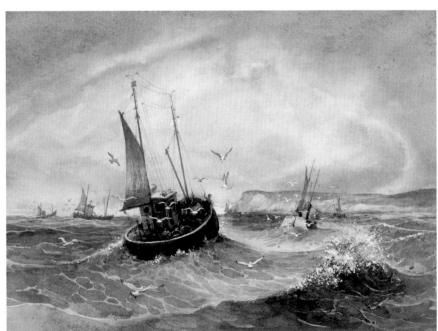

169 Fishing Boats
watercolour with bodycolour and pencil
10 x 13 ½ inches

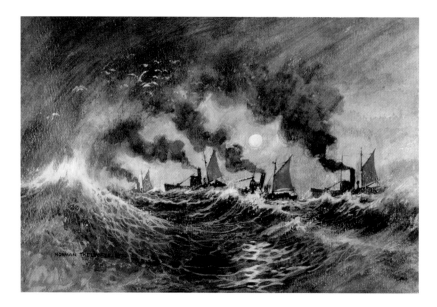

170 Drifters at Sea
signed and dated 1974
signed, inscribed with title and dated 1974
on reverse
watercolour, bodycolour and varnish
7 ¼ x 10 ½ inches

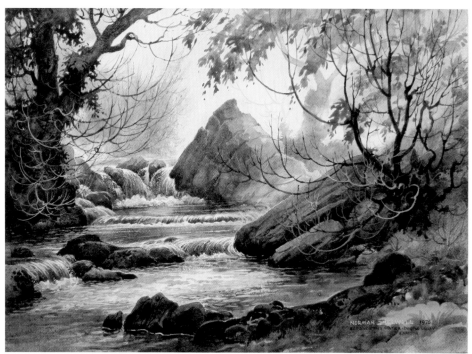

171 Badgworthy Water,
Doone Valley, Exmoor
signed, inscribed with title and dated 1976
watercolour with bodycolour
10 ½ x 14 ¾ inches

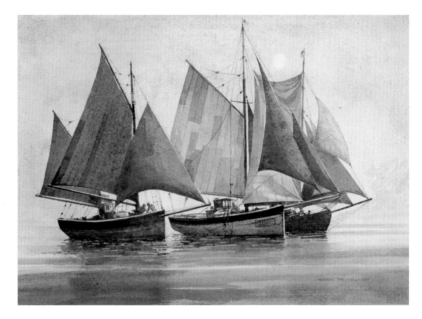

172 Boats on a Calm Sea
signed and dated 1979
watercolour with pencil
10 ½ x 14 ¾ inches

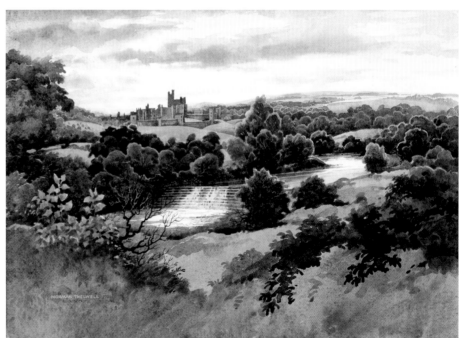

173 Alnwick Castle
signed, inscribed with title and dated 1981
watercolour
15 x 21 ¼ inches

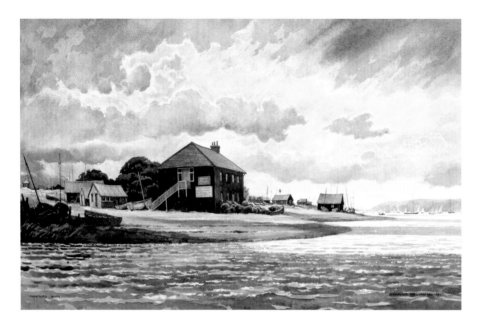

174 Mudeford. Hants
signed, inscribed with title and dated 1987
watercolour with bodycolour and pencil
13 x 20 inches

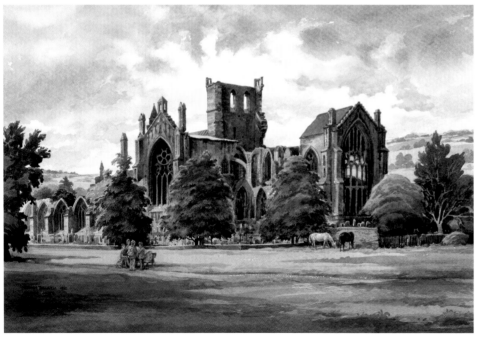

175 Melrose Abbey
signed, inscribed with title and dated 1982
watercolour
14 ¼ x 21 ¼ inches

176 Farm In Mid Wales
signed, inscribed with title and dated 90
watercolour
15 ½ x 19 ¼ inches

177 Clovelly N Devon
signed, inscribed with title and dated 1992
watercolour
14 ¼ x 21 ¼ inches

NORMAN THELWELL: ILLUSTRATED BOOKS AND VOLUMES OF CARTOONS

1957
Angels on Horseback – and elsewhere
London: Methuen & Co
(hardback, 9 ¾ x 7 ¼ inches, 96pp)
(issued as a paperback in 1970; collected in
Thelwell's Horse Box in 1971; collected in
Thelwell's Pony Cavalcade in 1981)

1958
Colin Willock
Rod, Pole or Perch. A field guide to anglers
London: Max Parrish
(hardback, 8 x 5 ¼ inches, 104 pages)

1959
Thelwell Country
London: Methuen & Co
(hardback, 9 ¾ x 7 ¼ inches, 96pp)
(issued as a paperback in 1970; collected in
Thelwell's Horse Box in 1971)

1960
*A Place of Your Own. A Guide to the Endless
Search*
London: Methuen & Co
(paperback, 6 ½ x 4 inches, 80pp)

1961
Thelwell in Orbit
London: Methuen & Co
(hardback, 10 x 7 ½ inches, 96pp)

Jennifer and Dorian Williams
Show Pony
Leicester: Brockhampton Press
(hardback, 8 ¾ x 5 ½ inches, 70pp; with
diagrams by Jean Goldsmith and photographs by
Jamie Hodgson)

1962
*A Leg at Each Corner. Thelwell's Complete Guide
to Equitation*
London: Methuen & Co
(hardback, 8 ¼ x 5 ¾ inches, 128pp)
(issued as a paperback in 1969; collected in
Thelwell's Horse Box in 1971; collected in
Thelwell's Pony Cavalcade in 1981)

Margaret Joyce Baker
Away Went Galloper
London: Methuen & Co
(hardback, 8 ¼ x 5 ¼ inches, 111pp)

A P Herbert
*Silver Stream. A beautiful tale of hare & hound for
young and old*
London: Methuen & Co
(hardback, 7 ½ x 5 inches, 57pp)

1963
The Penguin Thelwell
Harmondsworth: Penguin Books
(paperback, 7 ¾ x 5 ¼ inches high, 128pp)

1964
Top Dog. Thelwell's Complete Canine Compendium
London: Methuen & Co
(hardback, 8 ¼ x 5 ¾ inches, 128pp)
(issued as a paperback in 1976)

Caroline Ramsden
Racing Without Tears
London: J A Allen & Co
(hardback, 7 ½ x 5 inches, 88pp)

1965
Thelwell's Riding Academy
London: Methuen & Co
(hardback, 8 ¼ x 5 ¾ inches, 128pp)
(issued as a paperback in 1969; collected in
Thelwell's Horse Box in 1971; collected in
Thelwell's Pony Cavalcade in 1981)

1966
Drawing Ponies
London: Studio Vista (Studio Drawing Books)
(paperback, 6 ¾ x 7 ¼ inches, 56pp)
(reissued as *Thelwell's Pony Painting Book*, London:
Methuen Children's Books, 1972; reworked as
How to Draw Ponies. All the secrets revealed
London: Methuen Children's Books, 1982)

1967
Up the Garden Path. Thelwell's Guide to Gardening
London: Methuen &Co
(hardback, 8 ¼ x 5 ¾ inches, 128pp)
(issued as a paperback in 1972; collected in
Thelwell's Leisure Chest in 1975)

*Thelwell's Compleat Tangler. Being a Pictorial
Discourse of Anglers and Angling*
London: Methuen & Co
(hardback, 8 ¼ x 5 ¾ inches, 128pp)
(issued as a paperback in 1972; collected in
Thelwell's Leisure Chest in 1975)

1968
Thelwell's Book of Leisure
London: Methuen & Co
(hardback, 10 x 7 ¼ inches, 80pp)
(issued as a paperback in 1974; collected in
Thelwell's Leisure Chest in 1975)

1970
*This Desirable Plot: A Dream House-Hunter's
Nightmare*
London: Methuen
(hardback, 8 ¼ x 5 ¾ inches, 128pp)
(issued as a paperback in 1975; collected in
Thelwell's Leisure Chest in 1975)

1971
The Effluent Society
London: Methuen
(hardback, 10 x 7 inches, 96pp)
(issued as a paperback by Mandarin in 1978)

1972

Penelope
London: Eyre Methuen
(hardback, 8 ¼ x 5 ¾ inches, 96pp)
(issued as a paperback in 1975; collected in
Thelwell's Pony Panorama in 1988)

1973

*Thelwell's Three Sheets in the Wind. Thelwell's
Manual of Sailing*
London: Eyre Methuen
(hardback, 8 ¼ x 5 ¾ inches, 96pp)
(issued as a paperback in 1976)

1974

Belt Up. Thelwell's Motoring Manual
London: Eyre Methuen
(hardback, 8 ¼ x 5 ¾ inches, 128pp)
(issued as a paperback by Magnum/Mandarin
in 1977)

1975

Thelwell Goes West
London: Eyre Methuen
(hardback, 8 ¼ x 5 ¾ inches, 112pp)
(issued as a paperback by Magnum in 1979;
collected in *Thelwell's Pony Panorama* in 1988)

1977

Thelwell's Brat Race
London: Eyre Methuen
(hardback, 8 ¼ x 5 ¾ inches, 128pp)
(issued as a paperback in 1980)

1978

A Plank Bridge by a Pool
London: Eyre Methuen
(hardback, 10 x 7 ¼ inches, 160pp)
(issued as a paperback in 1980)

1979

Thelwell's Gymkhana
London: Eyre Methuen
(hardback, 8 ¼ x 5 ¾ inches, 96pp)
(issued as a paperback by Mandarin in 1981;
collected in *Thelwell's Pony Panorama* in 1988)

Thelwell's Pony Birthday Book
London: Methuen Children's Books
(hardback, 5 ¼ x 5 ¼ inches, 192pp)

1980

Thelwell's Horse Sense
London: Methuen
(hardback, 8 ¾ x 6 ½ inches, 32pp)
(the drawings were originally produced for
Thelwell's Riding Frieze, which was published by
Methuen's Children Books in 1977)

1981

*A Millstone Round My Neck. The Restoration of a
Cornish Water Mill*
London: Eyre Methuen
(hardback, 8 ¾ x 5 ¼ inches, 174pp)
(issued as a paperback in 1983)

1982

How to Draw Ponies. All the secrets revealed
London: Methuen Children's Books
(hardback, 7 ¼ x 7 ¾ inches, 56pp)
(based on *Ponies*, London: Studio Vista
(Studio Drawing Books), 1966)

Some Damn Fool's Signed the Rubens Again
London: Methuen
(hardback, 8 ¼ x 5 ¾ inches, 96pp)
(issued as a paperback in 1984)

1983

Thelwell's Magnificat
London: Methuen
(hardback, 8 ¾ x 5 ¼ inches high, 128pp)
(issued as a paperback in 1985)

1984

Thelwell's Sporting Prints
London: Methuen
(hardback, 9 ¾ x 13 ½ inches, 64pp)
(issued as a paperback in 1989)

1986

*Wrestling with a Pencil. The Life of a Freelance
Artist*
London: Methuen
(hardback, 10 x 7 ½ inches, 192pp)

1987

Play It As It Lies: Thelwell's Golfing Manual
London: Methuen
(hardback, 8 ¾ x 5 ¼ inches, 128pp)
(issued as a paperback by Mandarin in 1988)

1989

Penelope Rides Again
London: Methuen
(hardback, 8 ¼ x 5 ¾ inches, 112pp)
(issued as a paperback by Mandarin in 1991)

1992

The Cat's Pyjamas
London: Methuen
(hardback, 6 ¾ x 5 inches, 96pp)
(issued as a paperback by Mandarin in 1993)

*There is no more detailed pictorial
account of 50 years of change to the
English countryside than the work of
Norman Thelwell.*

Martin Plimmer, obituary, *Independent*,
10 February 2004

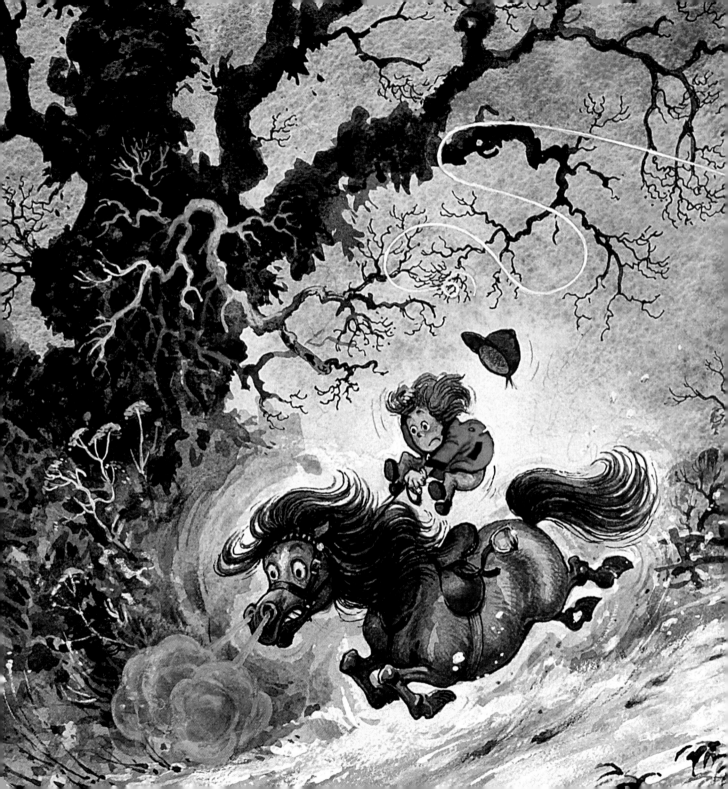